THE BEATLES

FAB FOUR CITIES

★ LIVERPOOL ★ HAMBURG ★
★ LONDON ★ NEW YORK ★

Richard Porter, David Bedford and Susan Ryan

ACC ART BOOKS

ISBN: 978 178884 091 0

British Library Cataloguing-in-Publication Data
A catalogue record for this book is available from the British Library

Every effort has been made to secure permission to reproduce
the images contained within this book, and we are grateful to the
individuals and institutions who have assisted in this task. Any errors
are entirely unintentional, and the details should be addressed to the
publisher.

*The Beatles, photographed by Fiona Adams in a bomb site off the
Euston Road, London, in April 1963. The photograph was chosen by
John Lennon for the cover of the* Twist and Shout *EP (Photo by Fiona
Adams/Redferns).*

Maps of Liverpool, Hamburg, London and New York City created by
Ashleigh Bedford.

Printed in Slovenia
for ACC Art Books Ltd., Woodbridge, Suffolk, England

www.accartbooks.com

**ACC
ART
BOOKS**

CONTENTS

INTRODUCTION

John Lennon once said: "We were born in Liverpool, but we grew up in Hamburg." To take this one step further, we would argue that The Beatles were born in Liverpool, grew up in Hamburg, reached maturity in London and immortality in New York.

These four cities have been connected for centuries, and so it is no surprise that they are also connected by The Beatles.

John, Paul, George and Ringo, like other boys born in Liverpool during the 1940s, were obsessed with all things American. In fact, as a city, it is fair to say that Liverpool looked more towards America than it did towards London and the rest of the UK. Boys were always on the lookout for American comics and candy, and Saturday mornings were spent at the local cinema watching American films. Ringo was so obsessed with America that he even considered emigrating, and ordered the paperwork from the US embassy to help him move there. John, at the age of 15, contemplated joining the Merchant Navy with his pal Nigel Walley, but following the phone call to Aunt Mimi, it is no surprise that it never happened. The spirit of adventure was always there. Was it a coincidence that John ended up in New York? The city may be on the other side of the Atlantic, but for a Liverpudlian, New York is just like a big version of Liverpool. This is not a unique, or even new concept; in 1851, *The Bankers' Magazine* called Liverpool "The New York of Europe".

Before The Beatles got anywhere near New York, grabbing the attention of 73 million Americans with their appearance on *The Ed Sullivan Show*, they had an unglamorous apprenticeship to serve in Hamburg. Playing sometimes up to eight hours a night, sleeping in a room with no heat, water or electricity, they learned their stagecraft in front of drunk, often disinterested clientele. This experience saw them conquer Hamburg and Liverpool, before a record deal, arranged with George Martin at Parlophone, resulted in a permanent move away from Liverpool, to London.

After their debut album, *Please Please Me*, hit the top of the charts in 1963, the group were soon playing in front of royalty, with a fanbase so fanatical, a popularity so intense, that the media coined the phrase "Beatlemania". Everywhere they went, the girls screamed. At Heathrow Airport those screams caught the ear of a passenger on his way home to New York: Ed Sullivan. From there, it was only a short hop to world domination.

To understand the incredible journey that The Beatles went on over such a short period of time, you need to explore the cities in which they lived and worked, to grasp the commonalities that played such key roles in their story. Each of the four cities – Liverpool, Hamburg, London, New York – was essential to their progress and success.

Was the pattern their lives would take pre-destined because of the connections between these four cities? When you examine the history of Liverpool, Hamburg, London and New York, you will see numerous connections before The Beatles were ever thought of. They are each significant port cities on major rivers, with a history of shipbuilding, global trade and a multi-cultural, cosmopolitan ethos that influenced those who lived in them; the cities think of themselves as within their respective countries, but not of them. They had musicians, artists, poets and free thinkers. They are cities of transit and immigration with a rich musical heritage, as will be examined in this book. With Liverpool as the birthplace of The Beatles, we will examine those links before, during, and after The Beatles' career.

So, travel to the Fab Four cities of Liverpool, Hamburg, London and New York to trace the history of The Beatles through the local experts from each city, and discover the similarities and idiosyncrasies of the cities that defined the greatest pop group of all time.

CONNECTIONS

Throughout the book, we've highlighted the Fab Four Connections that pull these cities together, showing the invisible lines that have linked Liverpool, Hamburg, London and New York City, both before and after The Beatles.

FAB FOUR CONNECTIONS

> Liverpool was connected to New York from 1840 by the White Star Line and the Cunard Line, both running frequent transatlantic cruises. Both Alf Lennon and Harold Harrison (John's and George's respective fathers) worked for the White Star Line, so you could say that The Beatles were connecting Liverpool and New York before the band even formed.

THE AUTHORS – MAKING CONNECTIONS

David Bedford (Liverpool and Hamburg)

I never understood why John would give up Liverpool, my hometown, for New York. That was until I visited the Big Apple for the first time, and I totally got it. I felt at home in New York, and John must have done too: the two cities have so much in common. The same can be said of Hamburg. It was only when I visited the city that I truly understood the similarities between Liverpool and Hamburg. I immediately felt at home in this great port city. People raised in a river city know what that means. Naturally, London is a city I have visited on numerous occasions over the years, and I've noticed Liverpool's similarities with the port of London and the docklands. To understand The Beatles, you not only have to experience Liverpool, but also Hamburg, London and New York as well.

Richard Porter (Hamburg and London)

As a Londoner, when I first went to Liverpool in the early 1980s, I was amazed how little there was for Beatles fans to do. There were no tours, no attractions, and the Cavern Club was still under a car park. However, I was taken straight away by how friendly people were, and how much they loved The Beatles. On visiting New York and Hamburg, many years later, I could see how similar they were to Liverpool. They are all ports, are very cosmopolitan, and very musical. Comparing them to my home city of London, I could see how The Beatles felt at home in each city.

Susan Ryan (New York City)

It's funny how some cities make you feel instantly comfortable, like you've arrived into a safe place where you belong. Liverpool and London are like that for me – as a native New Yorker, I have rarely felt as comfortable in another city as I do in those. I've been to both cities a couple of times since 1989, and each time I go I find more and more to love, and more and more similarities in each city to my own beloved New York. Standing at the Pier Head in Liverpool, for example, looking across the Mersey at the Wirral, I felt a distinct similarity to standing in lower Manhattan, looking at Brooklyn across the East River. It was beautiful and familiar. And walking around Soho in London, I was struck by the way the narrow streets and buildings reminded me strongly of the Greenwich Village of my youth. It's so easy to see why John Lennon loved living in New York and why he found the same comfort there as he did in his hometown – the similarities are striking, both in the infrastructure and in the sensibilities of the people. There's a forthrightness and a grittiness that the natives of each of the four cities associated with The Beatles share, and that connects them and makes the people from one of them feel comfortable in each of the other three.

PERSONAL CONNECTIONS

The similarities between the cities inspired us – David in Liverpool, Richard from London and Susan from New York – to collaborate on this book, each bringing our own local knowledge, perspective and expertise to the story. We are also grateful to Peter Paetzold and Matthias Fraider from Hamburg for their invaluable help and knowledge of that city. Richard and David are also indebted to Wolfgang and Andrea Bonisch, Alfred and Ilona Ebeling, and Simon and Petra Mitchell, our wonderful hosts for our trip to Hamburg in preparation for this book.

David Bedford.

Richard Porter.

Susan Ryan.

LIVERPOOL

1956

July — The Quarrymen are formed

1957

22 June — The Quarrymen play in Rosebery Street
6 July — John and Paul meet for the first time at St. Peter's Church
7 Dec — George auditions for The Quarrymen at Wilson Hall

1958

12 July — The Quarrymen record at Percy Phillips' studio

1959

29 Aug — The Quarrymen open the Casbah Coffee Club

1960

5 May — Allan Williams becomes The Beatles' manager
10 May — Audition for Larry Parnes. Tommy Moore becomes The Beatles' drummer
12 Aug — Pete Best auditions for The Beatles
16 Aug — Travelling to Hamburg for the first time
27 Dec — Litherland Town Hall: "Beatlemania"

1961

9 Feb — The Beatles' debut at The Cavern
6 July — Bill Harry launches *Mersey Beat*
28 Oct — Raymond Jones goes to NEMS and asks for *My Bonnie*
9 Nov — Brian Epstein visits The Cavern to see The Beatles
10 Nov — Operation Big Beat organised by Sam Leach

1962

24 Jan — The Beatles sign a management contract with Brian Epstein
16 Aug — Brian "dismisses" Pete Best
18 Aug — Ringo's debut with The Beatles
22 Aug — The Beatles are recorded at The Cavern by Granada TV

1963

3 Aug — The Beatles' final appearance at The Cavern

1964

10 July — Civic Reception at Liverpool Town Hall

1965

5 Dec — The Beatles' final Liverpool appearance, at the Empire Theatre

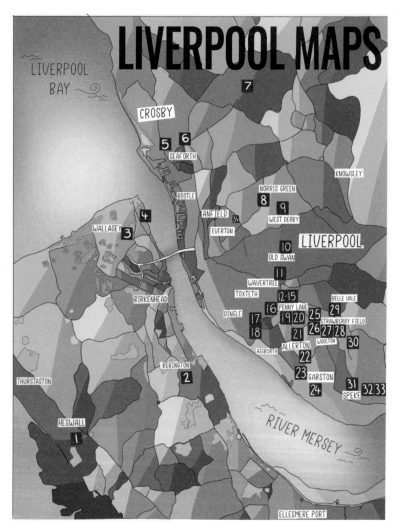

LIVERPOOL MAPS

LIVERPOOL BAY

CROSBY

⑦

⑤ ⑥
SEAFORTH

BOOTLE

KNOWSLEY

NORRIS GREEN
⑧ ⑨
WEST DERBY

ANFIELD ㉞
EVERTON

WALLASEY ④
③

⑩
OLD SWAN

LIVERPOOL

BIRKENHEAD

⑪
WAVERTREE

TOXTETH

⑫-⑮
BELLE VALE

DINGLE
⑯ PENNY LANE
⑰ ⑲⑳㉕ ㉙
⑱ ㉖㉗㉘ STRAWBERRY FIELD
㉑ WOOLTON
AIGBURTH ALLERTON ㉚
㉒
BEBINGTON ㉓ GARSTON
② ㉔
㉛ ㉜㉝
SPEKE

THURSTASTON

RIVER MERSEY

HESWALL
①

ELLESMERE PORT

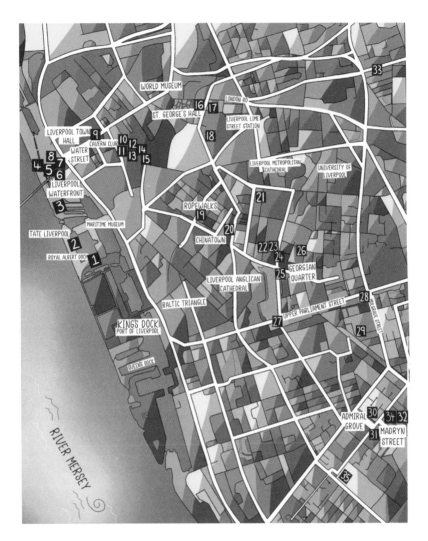

1. THE BEATLES STORY EXPERIENCE
2. ROYAL ALBERT DOCK
3. MUSEUM OF LIVERPOOL
4. FERRY TERMINAL
5. BEATLES STATUES
6. BRITISH MUSIC EXPERIENCE
7. CUNARD BUILDING
8. LIVER BUILDING
9. LIVERPOOL TOWN HALL
10. MATHEW STREET
11. THE CAVERN CLUB
12. LIVERPOOL BEATLES MUSEUM
13. THE GRAPES
14. THE WHITE STAR
15. FORMER SITE OF NEMS
16. ST. GEORGE'S HALL
17. THE EMPIRE THEATRE
18. LIME STREET STATION

19. JACARANDA COFFEE CLUB
20. THE BLUE ANGEL (FORMER WYVERN CLUB)
21. 4 RODNEY ST
22. LIPA (FORMER LIVERPOOL INSTITUTE)
23. LIVERPOOL INSTITUTE FOR PERFORMING ARTS
24. LIPA (FORMER LIVERPOOL ART COLLEGE, HOPE STREET)
25. FLAT 3 HILLARY MANSIONS, GAMBIER TERRACE
26. 36 FALKNER ST
27. TOXTETH LIBRARY
28. NEW CABERET ARTISTES CLUB
29. ROSEBERY STREET
30. 10 ADMIRAL GROVE
31. THE EMPRESS
32. 9 MADRYN ST
33. PERCY PHILLIPS' STUDIO
34. STATUE OF ELEANOR RIGBY
35. ST. SILAS SCHOOL

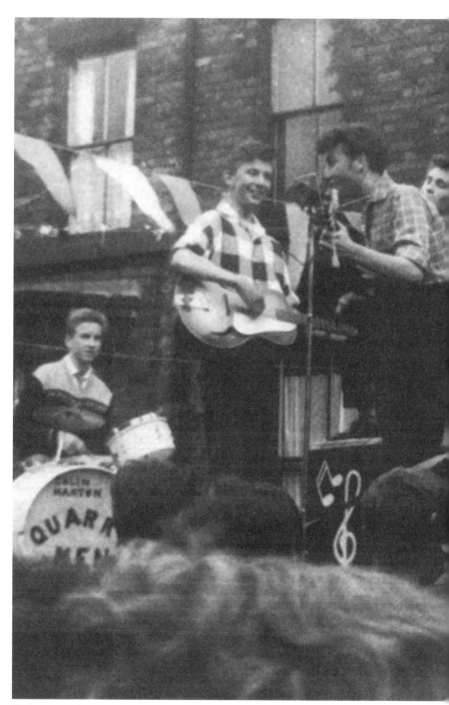

The Quarrymen performing in Rosebery Street, Liverpool, 1957. Photograph by Charles Roberts.

Lrypul, Litherpul, Leverpol, Liverpul, Litherpol, Lyverpol, Liverpull and Liverpool. Or as John Lennon called it: Liddypool.

Liverpool has had several variations on its name over the centuries, but throughout, the city has been shaped by its river, the Mersey. Having long since made the leap from fishing village to port, the city got its first wet dock in 1735, initiating two hundred years of boundless commercial growth. Liverpool became a melting pot, fed by limitless trade and migration; a city where cultures mingled and merged. Cotton, sugar and tobacco passed through the port in huge quantities, often borne by the slave trade that brought the city immense wealth. (In recent years the city has acknowledged and worked to atone for this shameful part of its history.) And people from Ireland, Europe, North America and elsewhere came and went – sometimes staying and making a home in the city.

By the time of the 1957 summer fete at St Peter's Church in Woolton, where the sixteen-year-old Lennon met Paul McCartney for the first time, Liverpool – with all its cosmopolitan influences – had become the perfect nursery for a new cultural phenomenon.

The city already had a vibrant live music scene, unrivalled elsewhere in Britain in the 1950s. The Celtic traditions of the large Irish, Scots and Welsh populations met with American influences, not least jazz, in the developing country music seen that saw Liverpool dubbed the 'Nashville of the North'. Indeed, the city had the biggest country music scene in Europe, with hundreds of groups by the later 1950s and, most importantly, hundreds of live music venues in which they could play.

Into that scene came Lonnie Donegan. He introduced skiffle, a kind of folk music flavoured with jazz and blues. Across the UK, young people purchased guitars on credit and formed bands; often, the only entry qualification was owning an instrument, and not even a proper one at that. Your mother's washboard and sewing thimbles would do; a pair of spoons or a wooden tea-chest with a broom handle as a bass was good enough. If someone owned a guitar or banjo, that was great. At Quarry Bank High School (now Calderstones School), John Lennon recruited his friends Pete Shotton, Bill Smith and Eric Griffiths into a skiffle group – The Quarrymen. Rod Davis was enlisted when he purchased a banjo, and they found themselves a drummer in Colin Hanton.

London-based Donegan was a frequent visitor to Liverpool. His appearance at the Liverpool Empire in November 1956 inspired Paul McCartney to buy a guitar, and George Harrison to seek the singer out for an autograph. Donegan's version of *Rock Island Line*, an old Huddy 'Lead Belly' Ledbetter song, was one of the few records bought by the young John Lennon.

In Liverpool, skiffle ran into the city's other cosmopolitan sounds, in particular the musical imports of the 'Cunard Yanks' – the ocean-liner stewards who brought records home to Liverpool from New York City – and the American servicemen at the USAAF base at Burtonwood, just outside the city. The version of rock 'n' roll that emerged was dubbed 'Merseybeat', and at the heart of this scene – so tied to Liverpool and its history – The Quarrymen evolved into The Beatles.

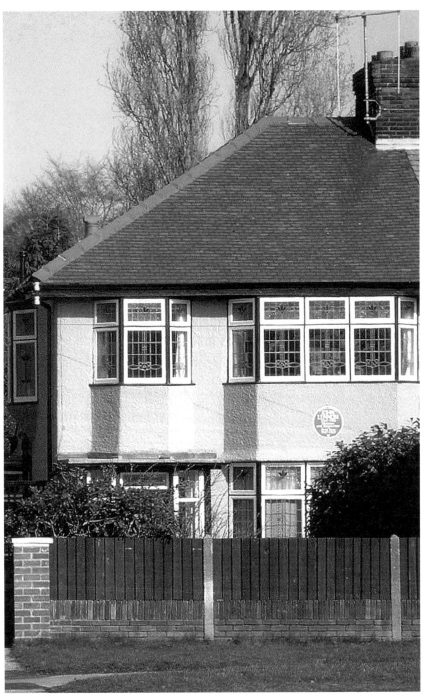

Today, John's main childhood home, 'Mendips', is a National Trust property.

FAB FOUR HOMES

JOHN LENNON

It is interesting to note the number of house moves the four Beatles made during their childhood. John and Paul made more than most: John's movement was due to the dysfunctional family life that brought significant disruption to his early years; whilst Paul's was down to his mother's occupation as a nurse. Ringo certainly had the most humble upbringing, though George's first few years were also spent in near poverty.

9, Newcastle Road, Wavertree

After his birth at Oxford Street Maternity Hospital on 9 October 1940, John Winston Lennon was brought home to 9, Newcastle Road, near Penny Lane, in the suburb of Wavertree, where he lived with his mother, Julia, his maternal grandparents and, when home from sea, his father, Alfred Lennon. John lived with his mother here until 1943, when they moved to Dairy Cottage in Woolton.

In 1944, Julia and John returned to 9, Newcastle Road, where they lived until 1946. With Alf Lennon not around, Julia met a soldier, Vernon 'Taffy' Williams, with whom she began a relationship and fell pregnant. Alf decided to take John away from Julia during her pregnancy, and they went to stay with his brother Sydney Lennon, who was living in Maghull, North Liverpool. However, Alf was soon back at sea and John was returned to his mother.

Julia gave birth to a girl named Victoria in June 1945, who was immediately put up for adoption. With her name changed from Victoria to Ingrid, the little girl grew up in North Liverpool before moving to Norway. John never met his half-sister, but he ended up back with his mother in Newcastle Road.

Julia then met John 'Bobby' Dykins, and the couple fell in love and decided they wanted to marry. Julia asked Alf for a divorce, but Alf refused. Julia and Bobby decided that they would "live together in sin", to use the parlance of the times.

In 2013, 9, Newcastle Road was put up for auction, where it sold for £480,000, way above the market value. The front steps now feature the message: "Welcome. Peace. Imagine".

Dairy Cottage, High Street, Woolton Village

John lived here for a short time with his mother and father from 1943 to 1944. The cottage was owned by his Aunt Mimi's husband, George Toogood Smith.

John's Aunt Harriet and her husband Norman Birch later lived in Dairy Cottage with their children Liela and David. After Julia Lennon was killed in 1958, John's half-sisters Julia and Jackie were made wards of court and were placed with Norman and Harriet as their legal guardians.

27, Cedar Grove, Maghull, Liverpool

This was the home of Alf Lennon's brother and sister-in-law, Sydney and Madge Lennon, and their daughter Joyce. When Julia fell pregnant with another man's child in 1944, Alf brought John here and he settled in well, soon feeling at home. However, when Alf went to sea again on 26 December 1944, John was taken back to 9, Newcastle Road.

When Alf returned from his latest voyage, John was soon returned to Uncle Sydney and Auntie Madge, and his cousin Joyce, in Maghull. Things went so well that Sydney and Madge considered adopting John, and even enrolled him in Dover Street School, with a view to him starting there in September 1945. However, sometime around April 1945, after another transatlantic trip, Alf turned up at Sydney's house, and took John back to his mother in Liverpool.

Flat in Gateacre

Sadly, we don't know the address of the one-bedroomed apartment that Julia, Bobby and young John shared in spring 1946. Julia's father, known as 'Pop' Stanley, and the rest of her family were not impressed with this arrangement; John, then just five years of age, was sharing a bed with his mother and her boyfriend. Pop intervened, insisting that John be removed from the "unsuitable" living conditions, and that Aunt Mimi should take him to Mendips.

Mendips, 251, Menlove Avenue, Woolton Village

After only a few weeks at Mendips, Alf came home from sea, because Mimi had told him John was unhappy. Alf then took John to Blackpool, even contemplating taking him to New Zealand. There was a discussion with John as to which parent he wanted to live with. He initially chose his father, but after Julia walked away crying, John ran after her and uttered the words forever commemorated in his solo song, *Mother*: "Mother don't go, daddy come home." However, John had to be returned to Mendips , where he spent much of the rest of his childhood.

He would return to the house again, in adulthood. In early 1963, he moved back in, this time with his wife. Cynthia. What an interesting atmosphere there must have been in that house! Julian Lennon was born soon after, and by the end of the summer, John, Cynthia and Julian, as well as the other Beatles, moved to London.

1, Blomfield Road, Springwood Estate, Garston

John began spending time at his mother's house in 1953, especially after arguing with Mimi.

Flat 3, Hillary Mansions, Gambier Terrace, Liverpool

When John was in art college, his best friend Stuart Sutcliffe, having been evicted from his flat at 9, Percy Street, Liverpool, moved into the largest of three rooms in this Gambier Terrace flat in the shadow of the Anglican Cathedral that was under construction. Although still based at Mendips, John moved into Gambier Terrace, sharing the flat with Stuart and Rod Murray. The Beatles rehearsed in the flat many times.

Gambier Terrace has been renovated and looks beautiful today, but back in the 1960s, it was part of Liverpool's red-light district. In August 1960, The Beatles headed to Hamburg's own red-light district, via Soho, London, which was also a red-light district. However, nothing they witnessed in Liverpool or London could have prepared them for Hamburg's Grosse Freiheit. While living at Gambier Terrace, The 'Beetles' hosted Beat poet Royston Ellis from London. He was the "man on the flaming pie" who suggested they changed their name from Beetles to Beatles, and discussed taking the group to London, to back Ellis on stage as he performed his beat poetry.

36, Falkner Street, Liverpool

When John married Cynthia on 23 August 1962, they had no home to live in. Brian Epstein allowed them to use his ground floor flat, but Cynthia felt isolated and vulnerable.

PAUL McCARTNEY

10, Sunbury Road, Anfield

Jim and Mary McCartney lived near to Liverpool FC's Anfield stadium. Mary worked in the nearby Walton Hospital, where Paul was born on 18 June 1942. He was brought home to Sunbury Road, but the family soon moved across the River Mersey to Wallasey on the Wirral.

92, Broadway Avenue, Wallasey

In 1942, they moved to 92, Broadway Avenue. However, after a short stay — and with too many bombs falling close to their home — they moved back across the River Mersey to the outskirts of Liverpool, into a temporary house in Knowsley.

3, Roach Avenue, Knowsley

This was a pre-fabricated home near to an armaments factory where Jim began work. These temporary homes were well loved by many of the occupiers and were often lived in for many years. However, the McCartney family would be on the move again soon. The pre-fabs in Roach Avenue are no longer there.

Sir Thomas White Gardens, Everton

The next move took them to the Everton district of Liverpool, nearer to Jim's family. They lived in a flat in an apartment block called Sir Thomas White Gardens in 1943. The block has since been demolished.

72, Western Avenue, Speke

Mary needed to return to work after Paul's younger brother, Mike, was born, but instead of resuming her nursing duties in a hospital, she was promoted to the role of district nurse and midwife on a new housing estate in Speke, South Liverpool. A house came with the job. The McCartneys first settled in 72, Western Avenue in 1947, before moving across the estate in 1950 when Mary resigned her post as midwife.

12, Ardwick Road, Speke

The family had to quickly find a new house, so they moved to 12, Ardwick Road, close to where George Harrison lived. With Paul and George both travelling to the Liverpool Institute by bus, they soon became friends.

20, Forthlin Road, Allerton

The McCartney family's final move, in 1955, was to 20, Forthlin Road, where Mary became the resident district nurse. Allerton was considered a better area than Speke, and was a step up the social ladder for the family. However, tragedy hit just one year after moving to this house, when Mary died of breast cancer in October 1956.

'Rembrandt', Baskervyle Road, Heswall

In 1964, when The Beatles became famous, Paul moved his father from Forthlin Road to a beautiful house he bought in Heswall, on the Wirral. Located in Baskervyle Road, the home was known as 'Rembrandt'. Paul still owns the property, and uses it when he returns to the area.

GEORGE HARRISON

12, Arnold Grove, Wavertree

George was born in this small terraced house on 25 February 1943, the fourth child of Louise and Harold Harrison. It was a Victorian terraced house with only two bedrooms upstairs and two rooms downstairs, with the four Harrison children – Louise, Harry, Peter and George – sharing a bedroom. There was no bathroom or toilet in the house. The Harrison family were on the waiting list for a bigger house for 17 years. Finally, just before George turned seven, they were moved to Speke, to a new housing development on the outskirts of Liverpool. Three years earlier, the McCartney family had moved to the same estate.

25, Upton Green, Speke

When the Harrison family moved into this new house in 1950, it must have felt like luxury to them. With three bedrooms, a bathroom and a toilet, and a small grass area outside to play on, it was a far cry from Arnold Grove. When George moved to the Liverpool Institute school, he shared the same bus ride every day with local lad, Paul McCartney, who was in the year above him. Harrison and McCartney became friends on the bus, and were soon learning guitar together at each other's houses. George's mum Louise believed in an open house, where all friends were welcomed. Paul became a regular visitor.

174, Macket's Lane, Woolton

The Harrisons moved to Macket's Lane in 1962, just as The Beatles were about to make their first record, so the house was soon bombarded with fan mail. Three years later, George moved his parents out of Liverpool to a small town called Appleton, near Warrington.

RINGO STARR

9, Madryn Street, Dingle

Richard 'Richy' Starkey was born on 7 July 1940 at 9, Madryn Street, where he lived with his mum and dad. It was a typical Victorian working-class house in the Dingle, one of the poorest

neighbourhoods in South Liverpool. The house had three bedrooms, but there was no inside toilet or bathroom.

When Richy, as he was known to his mum and dad, was only three years old, his parents divorced, with his father moving out of the family home and going to the bottom house in Madryn Street, where his own parents lived. Because the rent was high, and because Richy's mum Elsie was doing two jobs to pay the rent, it made sense to downsize. Sometime in 1945, they duly swapped homes with a family in a two-bedroom house.

10, Admiral Grove, Dingle

The two-bedroom property in Admiral Grove was just a smaller version of the Madryn Street house, so there was still no toilet or bathroom in the house. The rent was easier for Elsie, though she continued working two jobs to make ends meet. This is the house that Richy, who became Ringo, lived in until 1963, when, as one of The Beatles, he left for London.

By the time Ringo was in Rory Storm and the Hurricanes, they were the top group in Liverpool; and when he celebrated his 21st birthday here, there were approximately 80 people at the house, although nobody knows where they fitted them all! After The Beatles became famous, Ringo moved his parents out to Woolton, though Elsie would still return to the Dingle to see her friends on a regular basis.

Ringo's mother, Elsie, remarried when Ringo was in his early teens. Her new husband, Harry Graves, was a Londoner who had made his home in Liverpool.

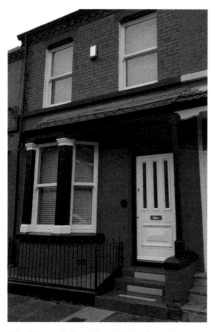

John: 9 Newcastle Road. The refurbished house has "Welcome. Peace. Imagine" on the steps.

John: Dairy Cottage, where John lived with his mother and father.

John: 27 Cedar Grove. Sidney Lennon's home, where John lived for a short time.

John: Aunt Mimi's house, known as "Mendips".

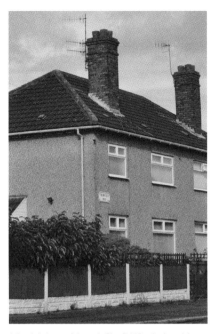

John: Julia Lennon's home in Blomfield Road, where John often stayed.

John: John shared a first floor flat in Hillary Mansions, Gambier Terrace, with Stuart Sutcliffe and Rod Murray.

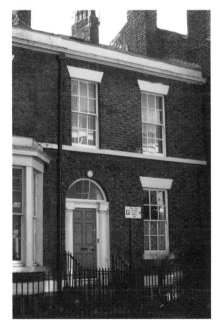

John: Brian Epstein's flat in Falkner Street, where John and Cynthia lived after they married.

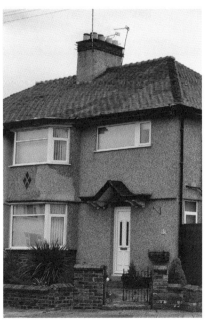

Paul: The McCartney family briefly lived here, on Broadway Avenue, on the Wirral.

Paul: Mary McCartney's job led the family to move to Western Avenue, in Speke.

Paul: The McCartneys moved to Ardwick Road, to a house closer to George Harrison.

Paul: Mary McCartney wanted better for her sons, so they moved to 20 Forthlin Road.

George: George Harrison was born here, at 12 Arnold Grove.

George: The Harrisons left Arnold Grove for this new house in Speke.

George: George's last childhood move was to this house on the edge of Woolton.

Ringo: The home in Madryn Street where Richard Starkey (aka Ringo Starr) was born.

Ringo: Elsie moved with her son to this house in Admiral Grove when he was five years old.

IMPORTANT LIVERPOOL CONCERTS

Quarry Bank School Hall, Allerton

October 1956

At school one day, John Lennon and his friend Geoff 'George' Lee were discussing music, when Geoff suggested to John that he should start his own group. Geoff even lent John his guitar – the first that John played. This new group, The Quarrymen, made their first appearance during the interval of a sixth-form dance at the school. The Quarrymen re-formed in 1997, and the surviving members are still performing today.

The Quarrymen's debut was here in the school hall.

The Cavern Club, Mathew Street

March 1957

Following their successful audition at Lee Park Golf Club, The Quarrymen made their first Cavern Club appearance just two months after it opened. It was nearly two years before The Beatles made their debut at The Cavern Club.

9 February 1961

This was The Beatles' lunchtime debut at The Cavern Club. Three years later to the day, on 9 February 1964, the group would appear for the first time on *The Ed Sullivan Show* in front of a television audience of 73 million people. It would be on 21 March 1961 that The Beatles made their evening debut at The Cavern Club.

The Cavern was dark and damp, with very little light. Having previously been used for storing fruit and vegetables, the rotting smell of decaying food was still ingrained in the walls. With only the stone steps in and out, and no fresh air, the atmosphere was hot and sweaty. The walls were painted white, giving rise to 'Cavern dandruff', where the paint would flake off on to your clothes. You couldn't lie about where you had been; your clothes and hair would stink of 'The Cavern'. It was in this club that The Beatles would go on to make approximately 292 appearances in just over two and a half years.

> The original Cavern owner Alan Sytner left Liverpool to help manage the Marquee Club in London.

The Cavern survived for many years, playing host to most of the biggest names in music. However, like most clubs, it had a lifespan. It opened and closed a couple of times in the 1960s. Despite protests from Beatles fans, the warehouses above The Cavern were demolished in 1973 and the cellar that housed the club was filled in with rubble, to make way for a proposed ventilation shaft for an underground railway. The bricks were sold off. However, the ventiliation shaft was never built and the lot eventually became a car park. In 1982, the cellar was unearthed and the club rebuilt under Cavern Walks, a shopping mall

The Cavern had two visits from important Londoners. On 13 December 1961, Decca's Mike Smith came to see The Beatles in concert before their audition on 1 January 1962. He was very impressed, though they failed to reproduce that level at the audition. The second visit was almost a year later when George Martin, The Beatles' new producer, visited The Cavern to consider whether he should record The Beatles in front of a live audience there. The conditions weren't suitable, so he decided against it. In the future, bands from London, Hamburg, New York and the rest of the world would all play at The Cavern Club.

that opened in 1984. This Cavern, which survives today, is deeper underground than the original, with 30 steps, and occupies about 50 per cent of the original site. By coincidence, the current fire exit of The Cavern can be found at the exact location of the original entrance.

9 November 1961

This was arguably The Beatles' most significant appearance at The Cavern, when Brian Epstein visited the club to see the band and decided to become their manager. Bill Harry, *Mersey Beat* editor, had arranged for Brian and his personal assistant, Alistair Taylor, to visit the club, which was only a few minutes' walk from Brian's shop, NEMS (North End Music Stores).

3 August 1963

This was the last Beatles appearance at The Cavern Club. Tickets were hard to get hold of, selling out in only 30 minutes.

The Empire Theatre, Lime Street

9 June 1957

The Quarrymen's first recorded engagement was here, at a Carroll Levis audition. In 1956, Paul McCartney had seen Lonnie Donegan in concert at the Empire and queued up afterwards for his autograph. George Harrison was also inspired by Donegan, tracking him down to a house in Speke to get his autograph.

18 October 1958	John, Paul and George appeared at the Empire as Johnny and the Moondogs, at one of the Carroll Levis 'TV Star Search' competitions.
28 October 1962	The Beatles appeared here on the same bill as Little Richard and Britain's Craig Douglas; they also performed as Douglas' backing band.
24 March 1963	Just after the release of their first album, *Please Please Me*, The Beatles appeared alongside Chris Montez and Tommy Roe. By their subsequent visit on 26 May 1963, they were on a UK tour with Roy Orbison, one of their heroes. They returned to the theatre again on 7 December 1963, with a special performance for The Beatles Northern Area Fan Club. They also recorded an episode of *Juke Box Jury* at 2pm, and a live performance for the BBC later that afternoon. The *Juke Box Jury* episode was broadcast that evening, followed by the concert, billed as, 'It's The Beatles', at 8.10pm. The watching audience was estimated at 23 million people, almost 45 per cent of the population.
5 December 1965	The theatre where Paul McCartney watched Lonnie Donegan way back in 1956 ended up being the venue for The Beatles' final appearance in Liverpool.

FAB FOUR CONNECTIONS

On 22 December 1963, The Beatles signed off at the Empire in Liverpool with a preview of their upcoming Christmas show, which was about to start at the Astoria, Finsbury Park, London. In 1964, The Beatles were off to New York and on an American and world tour, so by the time they played at the Empire again on 8 November 1964, they had hardly been seen in Liverpool all year. They truly were a global phenomenon by then.

Rosebery Street, Toxteth

22 June 1957

When Rosebery Street, situated in the Granby area of Toxteth, had a street party to celebrate Liverpool's 750th birthday, The Quarrymen played on the back of a lorry. Charlie Roberts took the first photographs of John and The Quarrymen here (see pages 12/13). The houses in Rosebery Street were demolished many years ago.

St. Peter's Church, Woolton

6 July 1957

This was the day that John Lennon met Paul McCartney at the St. Peter's Church fete in Woolton. Paul was only there because he had been brought along by John's childhood friend, Ivan Vaughan, to see John's group. That afternoon, The Quarrymen performed in the field behind the church, which is now part of a school.

If any single place is to be celebrated as the birth of The Beatles, then it is St. Peter's Church Hall. As a result of Ivan bringing Paul to meet John, the partnership between Lennon and McCartney was born. John handed Paul his guitar, and was astounded when he turned it upside down; this was how Paul had learned to play a right-handed guitar! His renditions of 'Twenty-Flight Rock' and part of 'Long Tall Sally' impressed the watching Lennon. It was not a difficult decision for John to make; he needed the talented Paul McCartney in his group.

The Quarrymen made several unpaid appearances in the church hall on Saturday evenings, including Paul's first shows. For Beatles fans, this is one of the most important places of pilgrimage; this is where The Beatles were born.

New Clubmoor Hall, Norris Green

18 October 1957

On this day, Paul McCartney made his official paid debut with The Quarrymen. Although he had previously appeared with the group at St. Peter's Church Hall, this performance, arranged by Nigel Walley, was the first occasion on which he (and the band) had been paid to perform.

The stars on the coffee bar ceiling at The Casbah.

Wilson Hall, Garston
7 December 1957

On this evening, George Harrison was invited to come and watch The Quarrymen here for the first time. After the performance, George played 'Raunchy' as his audition for John and the group on the top deck of a bus. By the end of 1957, John, Paul and George were together in the group. The hall has since been demolished and a Carpet Warehouse now stands on the site.

The Morgue,
Broadgreen
13 March 1958

Situated in an old house at 25 Oakhill Park, Rory Storm's short-lived club opened with Al Caldwell's Texans and The Quarrymen. The very first rock 'n' roll club in Liverpool, the original building, 'Balgownie', has since been demolished. After complaints from neighbours, police raided The Morgue and closed it down only six weeks after opening.

Casbah Coffee Club,
West Derby
29 August 1959

With The Quarrymen not having performed together since March, George had joined another group called The Les Stewart Quartet, who should have played for the opening of the Casbah. However,

after an argument in the group, George and Ken Brown quit. George then contacted John and Paul and got The Quarrymen back together. The re-formed group of John, Paul, George and Ken Brown opened The Casbah on 29 August 1959 in the basement of Mona Best's house, and The Beatles later played here more than forty times.

The interior of the club was hand painted by John, Paul, George, Pete Best, Ken Brown and anyone else they could get hold of. The 'Aztec' ceiling, hand-painted by John Lennon, is still there. Paul McCartney then used the paint left in various tins to create the 'rainbow' ceiling in the small area that would be the club's first stage. George helped to decorate the other walls and ceilings, while Pete was enlisted to help paint the 'Spider Room' and the dragon on the wall, with Mona's assistance. The stars on the coffee bar ceiling were painted by John, Paul, George, Stuart Sutcliffe and Pete. Even Cynthia, John's girlfriend, helped out, painting a 'Silver Beatle' on the wall.

It was while watching a TV show focusing on London's famous 2i's Coffee Bar that Mona Best was inspired to open her own coffee bar in her house.

As The Quarrymen took to the stage for the opening performance, John began by declaring: "Hi everyone, welcome to The Casbah. We're The Quarrymen and we are going to play you some rock 'n' roll."

Initially open once a week, The Casbah soon proved to be so successful that it opened every night. Set in the basement of a large house in the leafy suburb of West Derby, the club became the birthplace and cradle of the Liverpool music scene, hosting all of the popular Liverpool groups belonging to what would become known as the Merseybeat scene.

17 December 1960

With Chas Newby filling in on bass guitar for four appearances over Christmas, this was The Beatles' first official concert under that name in Liverpool, ironically billed as "Direct from Hamburg".

The Beatles were the last band to play The Casbah when it closed on 24 June 1962. The venue is open for private tours and is a must-see for any Beatles fan visiting Liverpool.

With the group billed as "Direct from Hamburg" at The Casbah in December 1960, many people assumed they were German. However the crowd soon recognised them as John, Paul and George from The Quarrymen, as well as Pete Best and Chas Newby from The Blackjacks.

Wyvern Club, Seel Street

10 May 1960

The Wyvern Club was opened by Allan Williams and was where The Silver Beetles auditioned for Larry Parnes. Johnny Hutchinson from Cass and the Cassanovas sat in with the group before their new drummer, Tommy Moore, turned up. Although they didn't get the job of backing Parnes' Liverpool-born singer, Billy Fury, he did offer them the chance to back another local performer, Johnny Gentle, on a two-week tour in Scotland. This was the beginning of The Beatles as a rock 'n' roll group. Today, the building that housed the Wyvern Club is home to the Blue Angel Night Club.

Lathom Hall, Seaforth

14 May 1960

The Beatles played Lathom Hall ten times, but their first appearance was as The Silver Beats (instead of The Silver Beatles, due a mis-understanding) on 14 May 1960. It closed in 2019.

Jacaranda Coffee Club, Slater Street

30 May 1960

The Jacaranda was opened by Allan Williams, who became The Beatles' first manager, at 23 Slater Street, Liverpool. Williams got them a drummer, gave them a place to play and, most importantly,

got them their gigs in Hamburg. John, Paul, George and Stuart (Sutcliffe) hung around the 'Jac' and badgered Williams to find them work. Stuart had already been commissioned to paint a mural in the basement, which he did with Rod Murray; sadly, this was destroyed by damp years later.

The Silver Beetles played regularly at the club. Then John, Paul, George, Stuart and Pete played here as The Beatles, just before heading off to Hamburg, in a rehearsal that turned into a performance. The Jac has reopened and is now a fantastic place to visit; an historic venue.

New Cabaret Artiste's Club, Upper Parliament Street

June 1960

Allan Williams booked The Silver Beetles at his and Lord Woodbine's illegal strip club at 174a, Upper Parliament Street early in 1960. They backed Janice, a stripper, on a small stage for one week, with Paul acting as drummer.

Litherland Town Hall

27 December 1960

Possibly one of the most important concerts The Beatles ever gave, at Litherland Town Hall, is considered to be the birth site of 'Beatlemania'. Having returned from Hamburg, they played at the Casbah and then here. For the first time, dancers rushed to the stage, clapping and cheering. The dance hall is no longer there and the building is now a health centre.

Top Ten Club, Soho Street

December 1960

Allan Williams decided to open his own Top Ten Club in Liverpool. He hired Bob Wooler to be the resident DJ and would let The Beatles be the resident group. However, it was only open for a few days before somebody burned it down. Nobody was caught, and Williams lost a lot of money in what could have been a goldmine. The building has been demolished and now has a garage on its site.

Allan Williams was inspired by Peter Eckhorn's Top Ten Club in Hamburg. Maybe the Soho Street location was an allusion to London's centre of music in Soho too?

Tower Ballroom, New Brighton

10 November 1961

The day after Brian first saw The Beatles at The Cavern, Sam Leach hosted the first of his famous Operation Big Beat concerts at the Tower Ballroom in New Brighton, on the Wirral. The Beatles went on to appear here twenty-seven times in total. With an audience of just over 4,000 people, it was the biggest crowd The Beatles played to in the UK. The ballroom burned down in the late 1960s.

Hulme Hall, Port Sunlight

18 August 1962

Hulme Hall in the Victorian industrial model village of Port Sunlight was the site of Ringo's first appearance with The Beatles on 18 August 1962. Eyewitness Ian Hackett described it: "There was a mass female chanting of 'We want Pete!' when they introduced their new drummer." Ringo coped well. You can still visit the hall; even though the stage is no longer there, the rest of the hall is authentic.

Port Sunlight was created by William Hesketh Lever in 1888 to house the employees of the Lever Brothers soap factory. The company became Unilever in 1930, and now has offices in Hamburg, London and New York. Not far from Port Sunlight is Birkenhead Park, which landscape designers used as a template for New York's Central Park.

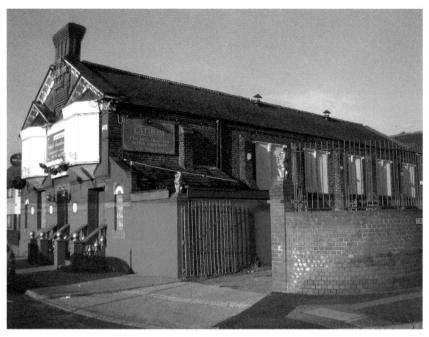

Lathom Hall, Seaforth, where The Beatles played on several occasions.

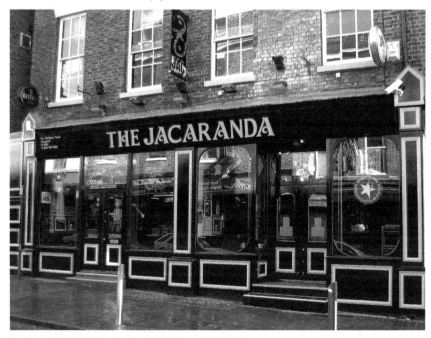

The Jacaranda Coffee Club, where Allan Williams became The Beatles' manager.

The former Litherland Town Hall, birthplace of Beatlemania, now a health centre.

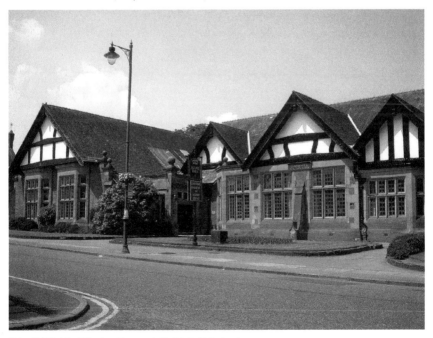

Hulme Hall, Port Sunlight, where Ringo made his debut with the band.

OTHER BEATLES SITES IN LIVERPOOL

LIVERPOOL CITY CENTRE

Mathew Street, The Cavern Club

For most fans, the place to start in Liverpool is Mathew Street, where you will find The Cavern Club, a replica of the original. Look out for the Wall of Fame, celebrating every artist who has played at the club since 1957.

Liverpool Beatles Museum, Mathew Street

Opened in 2018 by Pete Best, his brother Roag, and Paul Parry, this museum has many unique pieces of memorabilia owned by Pete from his time with The Beatles in Liverpool and Hamburg, plus items given to Roag by his father, Neil Aspinall, who worked as a Beatles roadie and sent home items from all over the world.

The Grapes, Mathew Street

Almost next door to the Liverpool Beatles Museum is The Grapes pub, one of the few original places here from the '60s, when Matthew Street was a forgotten back street in Liverpool. Go inside and see where John, Paul, George and Pete (Best) used to sit.

The White Star, Rainford Gardens

Just around the corner from The Grapes is the White Star. This traditional Liverpool pub is named after the White Star Shipping Line, owner of the ill-fated Titanic luxury passenger liner that was

registered in Liverpool and tragically sank on the way to New York. In the back room of the pub you can see where The Beatles used to meet up with Allan Williams and Bob Wooler.

Brian's links with the record companies in London, like Decca and EMI, were instrumental in getting auditions for The Beatles, and eventually a contract. Brian also had connections in Hamburg with Deutsche Grammophon, which he visited in 1961, and he probably walked down the Grosse Freiheit when The Beatles were performing there. Brian eventually set up a business relationship with New York lawyer Nat Weiss to handle the US dealings for The Beatles. This was NEMS, the Liverpool hub that connected The Beatles with London, Hamburg, New York and the rest of the world. It was The Beatles' recording of 'My Bonnie', made in Hamburg, that brought The Beatles to Brian's attention, beginning a partnership that took them from Liverpool to London and New York and beyond.

NEMS, Whitechapel Most recently a Forever 21 store, the shop that Brian Epstein managed, NEMS (North End Music Stores) was located here. It had the most extensive record department in Liverpool. It was from here that Brian masterminded The Beatles' career.

Stanley Street On Stanley Street, there is a statue of Eleanor Rigby, in honour of The Beatles song, sculpted by Tommy Steele, a former sailor who shot to fame in the 2i's Coffee Bar in Soho, London, becoming one of Britain's first rock 'n' roll stars.

Liverpool Town Hall, High Street

On 10 July 1964, The Beatles were awarded a civic reception by the City of Liverpool in recognition of their achievements. They were amazed when over 200,000 people turned out on the streets of their home town to welcome them. Many photographs were taken of The Beatles on the balcony of the Town Hall as they gazed over the streets filled with fans.

4, Rodney Street

Owing to the city's important maritime links, the US Consulate in Liverpool was one of the first in the world to be established following the American War of Independence. Situated on one of the finest roads in Liverpool, 4, Rodney Street was home to the first US Consul in Liverpool, James Maury, as now commemorated by a plaque on the wall. This location was also the private nursing home where The Beatles' manager, Brian Samuel Epstein, was born on 19 September 1934.

Liverpool Lime Street Station

This station was vital for Brian Epstein, who made numerous trips between Liverpool and London in search of a record deal, with The Beatles waiting in the local Punch and Judy Cafe for news.

FAB FOUR CONNECTIONS

Lime Street is mentioned in the classic Liverpool song, 'Maggie May', a regular favourite among all the Liverpool skiffle groups such as The Quarrymen. The Beatles did a version of it, called 'Maggie Mae', in their strongest fake Liverpool accents on the album *Let It Be*. The song was recorded in 1956 by a British band called The Vipers Skiffle Group, discovered at the 2i's Coffee Bar in London and signed by Parlophone, to be produced by George Martin.

Liverpool College of Art, where John Lennon met Cynthia Powell and Stuart Sutcliffe.

Liverpool College of Art, Hope Street

The Liverpool College of Art was originally part of the Mechanics' Institute. Stuart Sutcliffe enrolled in 1956, and John joined the following autumn, turning up in tight jeans and a long black jacket. He also met Cynthia Powell here, in lettering class. Until recently, the College of Art was part of John Moores University, and Moores was the art aficionado who bought Stuart's painting at the Walker Art Gallery; this enabled Stuart to buy his guitar and join The Beatles. The College has now been acquired by the Liverpool Institute for Performing Arts (LIPA) (see overleaf).

In front of the building is a fabulous piece of art called *A Case History*, celebrating those who attended the College of Art and Liverpool Institute. Here you can find suitcases with the names of Sir Paul McCartney, John Lennon and Yoko Ono, Stuart Sutcliffe and George Harrison.

Liverpool Institute and Liverpool Institute of Performing Arts (LIPA), Mount Street

The Liverpool Institute, a grammar school in Mount Street, originally opened as a school on 15 September 1837 (though it had previously been the Mechanics' Institute). In 1890, one half of the facility became the College of Art (see previous page). Paul and George were educated at the Institute, as were Quarrymen Ivan Vaughan and Len Garry, as well as two lads who would be with The Beatles in the '60s – Tony Bramwell and Neil Aspinall.

The building is now the Liverpool Institute of Performing Arts (LIPA). LIPA was set up by Paul McCartney, fulfilling a long-held ambition for his former school. As lead patron, he still takes a personal interest in the school, and comes back to award the degrees on graduation day.

St. George's Hall, St. George's Place

The neoclassical St. George's Hall dominates this area of Liverpool. Designed by Harvey Lonsdale Elmes, it was built to hold Liverpool's musical events in a grand ballroom that had an ornate mosaic floor. In a bid to recreate the Chelsea Ball, Allan Williams rented St. George's Hall for a party. He arranged for Stuart and John to create a few floats for the ball with some help from Paul and George. They created a magnificent guitar-shaped float, which was customarily destroyed at the end of the evening.

FAB FOUR CONNECTIONS

One of the most famous visitors to the Liverpool Institute was London author Charles Dickens, who made regular trips to Liverpool between 1838 and 1869. He gave many readings in St George's Hall and the Philharmonic Hall, and was even a Special Constable in Liverpool as part of his research. Dickens was also a regular traveller to New York. St. George's Hall also hosted fundraisers for the American Civil War.

In 1964 Astrid Kirchherr, the Hamburg photographer and friend of The Beatles, together with Max Scheler, travelled from Hamburg to London to photograph The Beatles on the set of *A Hard Day's Night* and in their London homes. They then came to Liverpool to photograph The Beatles' haunts and other Liverpool groups, and to record lunchtime sessions at The Cavern Club. Astrid also photographed as many Liverpool bands as possible on the steps of the plateau.

In 1980, in front of St. George's Hall, an estimated 25,000 people congregated on the plateau after the death of John Lennon, at an event organised by Beatles promoter Sam Leach. There was a link-up between New York and Liverpool as they held a candlelit vigil. Fans also gathered here after the announcement that George had died in 2001. In the gardens behind St. George's Hall you can find a tree dedicated to John, and one to George too. Opposite St. George's Hall on William Brown Street is the Walker Art Gallery, where you can see one of Stuart Sutcliffe's paintings.

Cunard Building, Pier Head

This was the former Headquarters of the Cunard Shipping line until 1960. Cunard, and its rival White Star Line, ran the regular route between Liverpool and New York.

A few other must-see visitor attractions

While at the Pier Head, take a trip on the **'Ferry 'Cross The Mersey'**, be photographed in front of **The Beatles' Statues**, go up the **Liver Building**, visit the **Museum of Liverpool**, or visit the **British Music Experience**, which is located in the Cunard Building. A visit to the **Royal Albert Dock** is a also must, with these historic buildings now converted into a selection of shops, restaurants and museums, including the **Merseyside Maritime Museum** and **The Beatles Story Experience**.

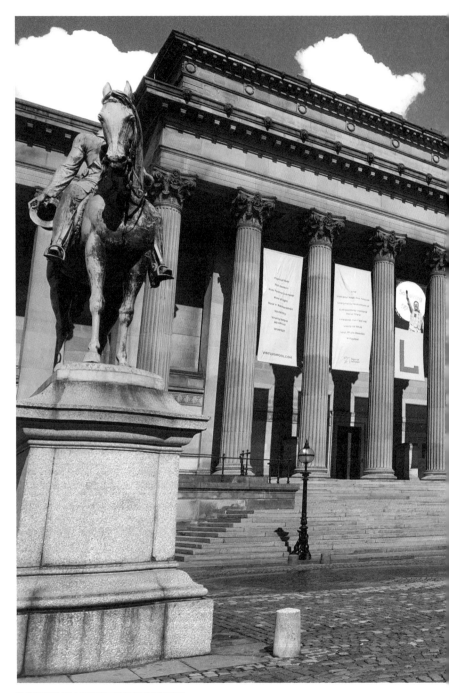

St George's Hall, a gathering point for Beatles fans.

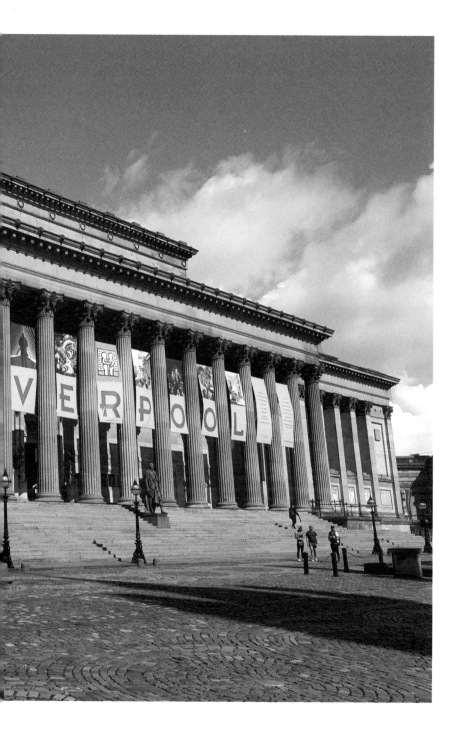

New York's Cunard Building still stands at 25 Broadway in Lower Manhattan. During the 1950s and '60s, those Liverpool stewards who had time in New York between voyages would go shopping, buying suits, cameras and, importantly for the Liverpool music scene, records. These sailors, who became known as 'Cunard Yanks', brought records to Liverpool from New York, and gave them to their family and friends in groups back home, before they were released in the UK. Outside the Cunard Building on the Strand, Liverpool, is a bench celebrating the Cunard Yanks.

HERE, THERE AND EVERYWHERE

For the rest of the important places in Liverpool, you will need to travel. A professional Beatles tour is a good option, enabling you to see as many sights as possible.

Percy Phillips' Studio, Kensington

Remarkably, the embryonic Beatles only recorded in one location in Liverpool, such was the city's lack of studio facilities (later leaving them little choice but to relocate to London). This small studio tucked inside a Victorian terraced house at number 38, Kensington is where The Quarrymen made their first demo record, on 12 July 1958. It was a disc that eventually became one of the most historic recordings in popular music. John, Paul, George, Colin Hanton and John Duff Lowe paid seventeen shillings and sixpence (87.5 pence) and cut a two-sided disc made of shellac. They couldn't afford to pay for a tape and so the recording was made straight to disc. The five-piece ensemble recorded Buddy Holly's 'That'll Be The Day' and 'In Spite Of All The Danger', an original McCartney-Harrison tune. It was seen as Paul's song, with George providing the guitar solo.

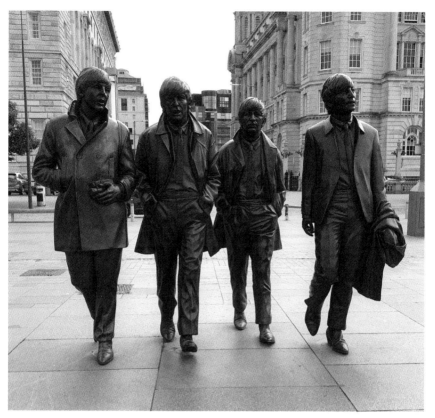

The Beatles statues at the Pier Head, sculpted by Andrew Edwards, cast by Chris Butler at Castle Fine Arts Foundry, and donated by Cavern City Tours.

Colin Hanton, drummer with The Quarrymen, later recalled that famous first recording: "All I remember was this back room with electronic equipment in the corner. We set up our equipment with me in the corner and the lads with their guitars; there were no amps,

The equipment used on The Quarrymen's first recording had been purchased by Percy Phillips from EMI in London.

it was all-acoustic. John Lowe was over by the wall on the piano. I was hitting the drums and he said that they were too loud, so I tried again but there was still the same problem which was finally fixed by putting a scarf over the snare to soften it and keep it as quiet as possible.

"John Duff Lowe reckons there was one microphone hanging down from the ceiling, which picked everything up. He was complaining because he said we should get the tape, which was a pound, but we just had enough each – three shillings and sixpence (17.5 pence). He gave us the disc and off we went. It was a big thing. How many people had records like popular crooner, Matt Monro? So, we had a record too, and could listen to ourselves. I can still remember it so clearly."

In August 2005, Hanton returned to Kensington for the unveiling of a plaque to commemorate this first recording. John Duff Lowe was also in attendance, as well as Julia Baird, John's half-sister. Radio presenter Billy Butler was also on hand for the festivities.

The Dingle

The Dingle is an area within Toxteth synonymous with Ringo Starr. He was born at **9, Madryn Street** and lived in **10, Admiral Grove** from the age of five (see pages 22-23) At the top of Admiral Grove is **The Empress** pub, which celebrates Liverpool's seafaring heritage.

The front of The Empress pub is on the cover of Ringo's first solo album, *Sentimental Journey*. The video for the song, 'Sentimental Journey' was partly filmed in London at the Talk of the Town, with a backdrop of The Empress behind Ringo.

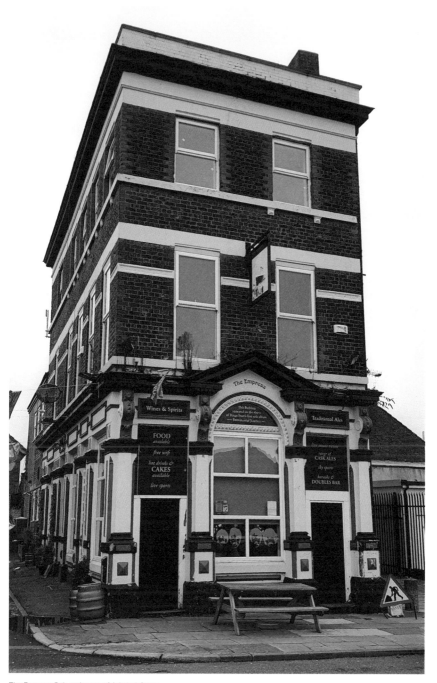

The Empress Pub at the top of Admiral Grove.

A little further up High Park Street towards Admiral Street is **St. Silas School**. This school was attended by Ringo Starr, Alf Lennon and Billy Fury – Britain's first rock 'n' roll star, who was whisked off to London to find fame. David Bedford (your author) also attended this school.

John's Aunt Mimi was born close by, at **21, Windsor Street**, which has since been demolished. Over the road from Mimi's birthplace is **Toxteth Library**, which was opened in 1902 by Andrew Carnegie, who subsequently funded six libraries in Liverpool. The Beatles performed at Carnegie Hall, also funded by Andrew Carnegie, in New York on 12 February 1964 (see page 162).

Aigburth

By Sefton Park Lake is the **Sefton Park Hotel** at **37, Aigburth Drive**. The ground floor of this building was rented by Stuart Sutcliffe's family.

FAB FOUR CONNECTIONS

Stuart Sutcliffe visited 37 Aigburth Drive on a return trip from Hamburg with his new fiancée, Astrid Kirchherr. It was while living here that Stuart's family heard the terrible news that he had died in Hamburg at the age of 21, after suffering a brain haemorrhage.

Across the road from the hotel is **Sefton Park lake**, where John Lennon's parents, Alf and Julia, first met. Alf, as a merchant seaman, made the regular journey from Liverpool to New York, and he went AWOL there, spending some time on Ellis Island, before sailing around the world trying to get home.

Penny Lane (Allerton, Mossley Hill and Wavertree)

Most of the subjects in the song 'Penny Lane' are not on the road of Penny Lane, but on the roundabout at the top, called Smithdown Place, known locally as the 'Penny Lane Roundabout'. This district is also called the 'Penny Lane area', as three Liverpool suburbs – Mossley Hill, Wavertree and Allerton – all meet here too.

John lived at 9, Newcastle Road (see page 17), within the Penny Lane area, with his mother Julia. When Aunt Mimi enrolled him into Dovedale School on Herondale Road, he would take the bus from 'Mendips' to Penny Lane every day. So, until he was 11 years old, John was a regular visitor to the street.

George Harrison lived up the road at 12, Arnold Grove (see page 22), and would walk through Penny Lane to get to Dovedale School. When he was seven, the Harrisons moved to Speke, so George would have caught the bus to Penny Lane every day. Like John, Penny Lane was in the ears and the eyes of George throughout his childhood. Paul McCartney also travelled here to sing in the choir of St. Barnabas Church, on the roundabout.

The Barber Shop. It used to be Bioletti's but is now called Tony Slavin. It is in the same location, on the roundabout, but today it has a different owner from when the song was written.

The Bank. There were three banks on the roundabout in the 1960s. What is now Penny Lane Surgery is most likely to have been where the banker with the motor car didn't need his "mac in the pouring rain", because he walked out of the bank and into his car, driving home. No wonder the "children laughed at him behind his back".

The Fireman. He could have been at Penny Lane, though the fire station itself is just under a mile away. Paul would have passed it every day on his bus trip, which took him through Penny Lane on the way to school.

Although 'Penny Lane' was written about the street in Liverpool, the promotional film for the song was mainly shot in London, with a few clips of the Smithdown Place roundabout woven into the footage.

The shelter in the middle of the roundabout. The shelter is still used as a bus terminal, though the building has been closed for years. "The Pretty nurse... selling poppies from a tray" refers to Beth Davidson, the girlfriend (and, later, wife) of John's best friend, Pete Shotton. So, John put his best friend's wife in a Beatles song, and nobody knew.

Quarry Bank School, Allerton

Now called Calderstones School, the former Quarry Bank School was where John Lennon and his friends formed The Quarrymen. (See page 28 for more on Quarry Bank as a venue for the band.)

Strawberry Field, Beaconsfield Road, Woolton

One of the most popular Liverpool locations for Beatles fans is Strawberry Field. A brand-new visitor centre was opened at the site of the former children's home in September 2019 by the Salvation Army, allowing fans to walk around the grounds, as well as study the history of the place that was so special to John Lennon.

FAB FOUR CONNECTIONS

The original mansion that stood on these grounds until 1971 is almost identical to the Dakota Building in New York where John and Yoko lived together. It is not known if John ever recognised the similarity, or whether it was subconscious or simply a coincidence.

When John was younger, he and his friends climbed over the wall on Vale Road at the back of the Strawberry Field grounds, and played among the trees of the Salvation Army orphanage. When he climbed that wall, he left normality behind, and entered his imaginary playground where "Nothing is real".

Eleanor Rigby, St Peter's Church

The graveyard alongside St Peter's Church is the location of the grave of Eleanor Rigby. The lady died in 1939, and lived in Woolton village. She was not famous, so it seems unlikely that any of The

Beatles would have known about her. Is it a coincidence? Or did Paul see the gravestone? Paul says that he got the name Eleanor from his actress friend Eleanor Bron, and Rigby from a wine merchant in Bristol called Rigby and Evans. He put the two names together and got Eleanor Rigby.

However, it seems too much of a coincidence for Paul not to have seen the grave. After all, when anyone walks into a graveyard, they naturally start reading the names on the graves. The story of Eleanor Rigby is also about a lady who was "buried along with her name", with Father McKenzie "wiping the dirt from his hands as he walks from the grave". Paul must have seen the name but forgotten about it. All those years later, when he put the Eleanor and Rigby together, the reason it sounded right to him was surely because his subconscious was telling him that he had seen it years before.

Speke Airport

The former Speke Airport is now a hotel and industrial estate. The airport moved to a new site and was renamed Liverpool John Lennon Airport. Julia Lennon's partner, John Dykins, worked at the airport restaurant, and helped John get a job there.

The Beatles travelled from Liverpool to Hamburg in April 1962 from Speke Airport, as well as to London in September 1962 to begin recording their first single. During the Second World War, planes brought over from New York and other American ports to Liverpool were taken out to Speke Airport to be assembled and then flown south to join the war effort. Sadly, many of those planes would take part in bombing German cities such as Hamburg.

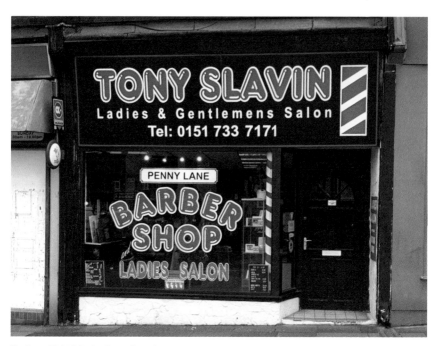

The former Bioletti's barbershop on Penny Lane.

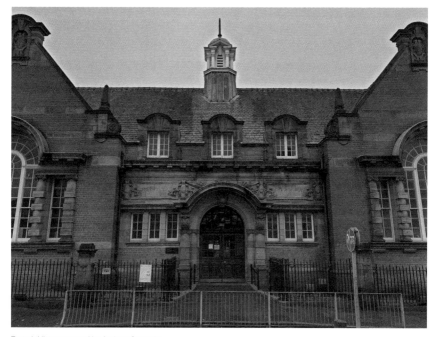

Toxteth Library, opened by Andrew Carnegie.

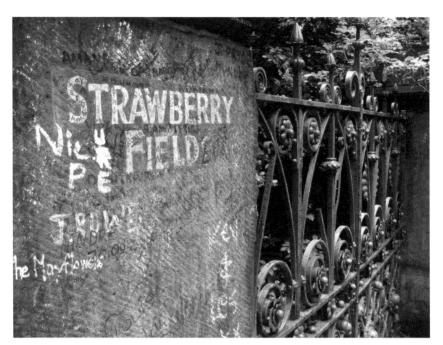

The famous replica gates at Strawberry Field; the originals are in the grounds.

The former Speke Airport.

HAMBURG

1960

17 Aug–3 Oct — The Beatles perform at the Indra Club, Grosse Freiheit 64

4 Oct–28 Nov — The Beatles move to the Kaiserkeller, Grosse Freiheit 36

21 Nov — George Harrison is deported for being under 18 whilst out after curfew

29 Nov — Without George, the other Beatles perform at Studio X, situated in the Kaiserkeller

5 Dec — Paul McCartney and Pete Best are arrested and deported for attempted arson. John Lennon returns to Liverpool a few days later

1961

27 March–1 July — The Beatles return to Hamburg to perform at the Top Ten Club on the Reeperbahn

1962

11 April — John, Paul and Pete arrive in Hamburg to be told that Stuart Sutcliffe died the previous day

13 April–31 May — The Beatles open the new Star Club at Grosse Freiheit 39

1–14 Nov — The Beatles, now with Ringo Starr, return to the Star Club with 'Love Me Do'

18 Dec–1 Jan — The Fab Four are back at the Star Club for the last time

1966

26 June — The Beatles make a final Hamburg appearance, at the Ernst Merck Halle

HAMBURG MAPS

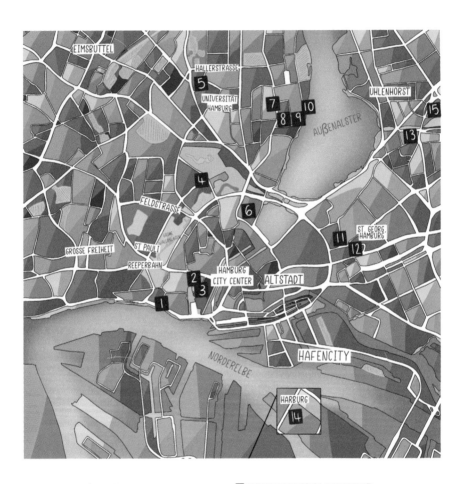

1 BRITISH SEAMAN'S MISSION
2 DEUTSCHES SEEMANNSHEIM/BRITISH SEAMEN'S MISSION
3 KRAMERAMTS-WOHNUNGEN (KRAYENKAMP 10)
4 ERNST MERCK HALLE
5 MUSIKVERLAG OKTAVE
6 STEINWAY-HAUS
7 KEMP'S BAR
8 POLYDOR
9 DEUTSCHE GRAMMOPHON GESELLSCHAFT
10 HARVESTERHUDER WEG
11 AKUSTIK STUDIO
12 HAUPTBAHNHOF
13 FACHHOCHSCHULE FUR GESTALTUNG
14 FRIEDRICH-EBERT-HALLE
15 UNIVERSITY OF FINE ARTS

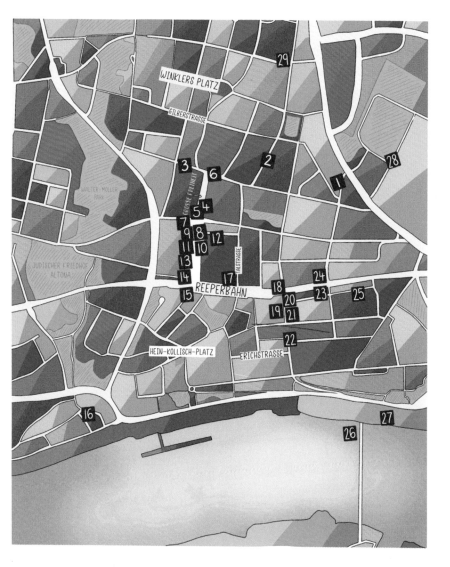

1 HOTEL GERMANIA
2 JÄGERPASSAGE
3 BAMBI KINO
4 INDRA CLUB
5 DER LACHENDE VAGABUND
6 BÄCKEREI SCHUMANN/SCHUMANN BAKERY
7 GRETEL AND ALFONS
8 KAISERKELLER (INCLUDING STUDIO X)
9 ST.JOSEPH-KIRCHE
10 HOTEL SAFARI

11 STAR CLUB
12 CHUM YUEN POON
13 HARALD UND LORE
14 BEATLES-PLATZ
15 ERDMANN LEDERBEKLEIDUNG
16 FISCHMARKT
17 TOP TEN CLUB
18 REEPERBAHN
19 SALON HARRY
20 DAVIDWACHE

21 PAUL HUNDERTMARK JEANS & WESTERN STORE
22 HERBERTSTRASSE
23 SPIELBUDENPLATZ
24 GRAND HOTEL MONOPOL
25 PANOPTIKUM
26 ST.PAULI-LANDUNGSBRUCKEN
27 HARD ROCK CAFE HAMBURG
28 HEILIGENGEISTFELD
29 LEDER DSCHUNGEL

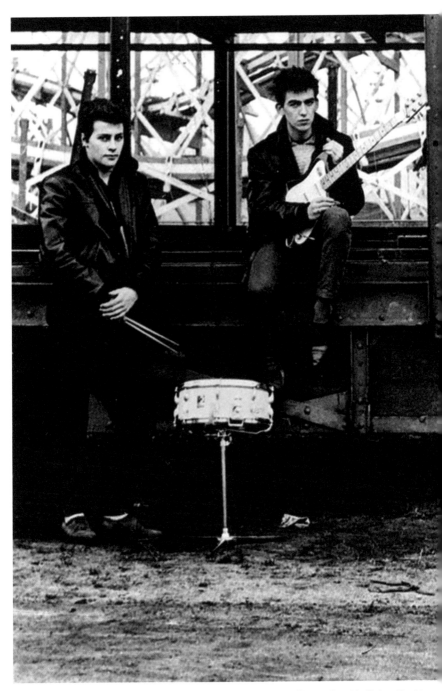

The line up in October 1960, at the Dom Fairground, Hamburg. Photograph by Astrid Kirchherr, Copyright Ginzburg Fine Arts.

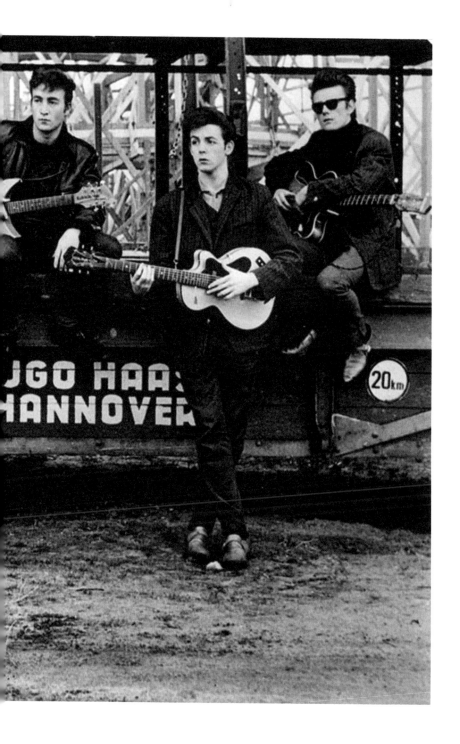

If the Beatles were born in Liverpool, their industrious apprenticeship was served in Hamburg.

They arrived in August 1960, an enthusiastic but unpolished, unsigned five-piece with quiffs and a repertoire of rock 'n' roll covers. By the time of their final residency at the city's Star Club, two and half years later, the band been honed to a tight, mop-topped unit of four, and had released their debut single, 'Love Me Do'.

Allan Williams, the band's first manager, drove The Beatles to Hamburg from Liverpool via London. When Paul, John, George, and early bandmates, Stuart Sutcliffe (bass) and Pete Best (drums), unfolded themselves from Williams' Austin van, they discovered a city not unlike their own.

In common with Liverpool (and London and New York), Hamburg lies not on the coast but on a river, the Elbe. In the nineteenth century, it became the leading port on mainland Europe, a key gateway in the flow of people and goods from Europe to North America. Most of the migrants who came through Hamburg — many fleeing persecution in Eastern Europe — would also pass through Liverpool on their way to the New World.

The city has long been regarded as fiercely independent; a cosmopolitan Hanseatic city-state of old that identifies with the values of commerce and liberalism, at odds with Prussian authoritarianism and Catholic moralism. Historian Helmut Bohme described Hamburg as "the most English city on the continent", due in part to its traditions of continuity, gradual reform and free trade.

The Beatles' years in Hamburg were spent in and around St Pauli, a scruffy district situated directly west of the city centre, on the north shore of the Elbe. The area lies behind the old city wall, and was once officially a part of Denmark. As far back as the 1600s, the 'good' Hamburgers, with moral rectitude, placed whatever they considered 'dirty' on the far side of the wall: prostitutes, drinking dens, artists, Catholics, Jews. St Pauli's proximity to the harbour, with its transient workers, contributed to the area's anatomy of marginal people and illicit trades. At its heart was — and still is — the Reeperbahn, taking its name from the ropemakers who settled there in 1625; the long, straight road was well suited for the stretching, winding and tarring of hemp.

In the 1930s, St Pauli was the setting for clashes between Communists and Nazis, in the district's defiantly proletarian backstreets. Once in power, the Nazis worked to 'clean up' the area: they corralled prostitutes into the gated bordello of Herbertstrasse and persecuted so-called 'asocials' (particularly habitual prostitutes) and homosexual men. Chinese residents suffered deportation in 1944.

By the time The Beatles arrived in St Pauli in 1960, the area had reestablished its licentious reputation. It had also built on its pre-war renown for incubating liberal, youthful forces, not least through the performance of live music. In the 1930s, St Pauli had been the birthplace of the Swingjugend (Swing Kids), a jazz and swing-inspired movement of proto-beatniks that spread from Hamburg to Berlin and other German cities, challenging the orthodoxy of the Nazi government. The Cap Norte, in the basement of Grosse Freiheit 36 – later the site of the Kaiserkeller Club, where The Beatles played during their second spell in Hamburg – had been a focus for the Swingjugend until it was raided and closed by the Gestapo in 1942.

It has been said that the children of the Swingjugend grew up to become the Exis, a bohemian clique of middle or upper-middle-class art-student types that emerged in Hamburg in the late 1950s. Advocates of existentialism, they wore long black scarves and leather jackets, their straight hair combed across their foreheads. They were the post-Nazi babies. Astrid Kirchherr, Klaus Voormann and Jürgen Vollmer, whose lives and careers would become entwined with The Beatles, were immersed in the Exis subculture.

The cool, sleek Exis co-existed in Hamburg with the energetic devotees of rock 'n' roll and skiffle. Lonnie Donegan's cover of 'Rock Island Line' found a receptive audience here, just as it had in Liverpool, while Bill Haley and the Comets caused a riot when they played at the Ernst Merck Halle in October 1958.

In the late 1950s, a St Pauli entrepreneur named Bruno Koschmider sought to tap this new market. He began booking British bands to play at his club, the Indra, in the heart of St Pauli; and in August 1960, Allan Williams, Koschmider's contact for Liverpool bands, delivered The Beatles for their first Hamburg shows.

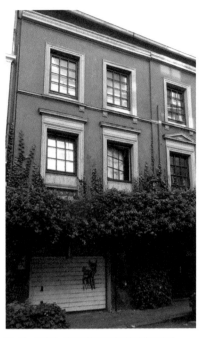

The Bambi Kino, where The Beatles lived for a few weeks in 1960.

Eimsbütteler Strasse 45a, the Kirchherr family home.

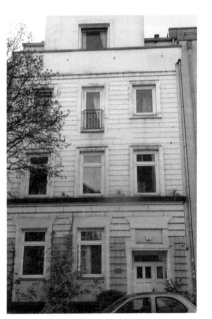

Hotel Germania, where The Beatles stayed in November 1962.

By 1966, the band were enjoying luxury accomodation at the Hotel Schloss Trembüttel.

FAB FOUR HOMES AND HOTELS

Bambi Kino, Paul-Roosen-Strasse 33

The Bambi Kino was located at Paul Roosen-Strasse, 33, at the northern end of the Grosse Freiheit. Bruno Koschmider wanted his group to be as near to his Indra and Kaiserkeller clubs as possible. As these clubs were a matter of minutes from the Bambi Kino, he thought it made sense to let the boys sleep here. This small cinema had a couple of windowless rooms at the back, located near to the men's toilets. It was not the luxury they had hoped for. The rooms were basic – a couple of metal-framed beds with mattresses, and they had to use the communal toilets to get washed. Paul and Pete shared one room, with John, Stuart and George in the other.

It was here that the famous incident took place that would lead to The Beatles' deportation from Hamburg. The story goes that when they were leaving the premises, Paul and Pete set fire to a condom to create enough light for them to get all of their things out. However, when you read both Paul's and Pete's reports for the authorities to get them back into Germany, the condom wasn't mentioned; that was probably wise.

In a letter to Herr Knopp, Chief Officer of the Aliens Police, Paul McCartney said: "The piece of material we burnt was about 3 centimetres wide and 1.5 metres long, and at that time it was serving no purpose at all. Of course, we realise that we damaged some of Herr Koschmider's property, but the fact is that we know we did it with NO malicious intent."

In his official police statement, Pete Best refers to the burned item as a "piece of cord or tape nailed to the wall (this was the bare stone wall and it was damp also), and in our moment of stupidity we set the cord alight in several places. However, upon seeing the dense smoke, we immediately put out the small flames and when we were quite positive that everything was under control and back to normal, we returned to our room and went to sleep."

So, it wasn't a condom, according to these descriptions, and it caused some smoke as well as flames. However, in subsequent interviews, it has always been said that it was a condom on the wall. Either way, it was definitely not attempted arson as Koschmider tried to suggest. Unfortunately for Paul and Pete, the incident meant a night in the nearby police cells at Davidwache, before being deported back to Liverpool.

Deutsches Seemannsheim, Krayenkamp 5

There are two seamen's missions in Hamburg. This one, based on Krayenkamp, was where Rory Storm and the Hurricanes, including Ringo, were billeted in 1960 when they joined The Beatles out in Hamburg.

Eimsbütteler Strasse 45a

This was the home of photographer Astrid Kirchherr's family. Stuart Sutcliffe moved into Astrid's third floor apartment not long after they fell in love in late 1960. The Beatles were soon spending plenty of time here, being 'mothered' by Astrid's mum, Nielsa, on the second floor that Astrid and her mother shared. Astrid's father was a former executive of the German branch of the American Ford Motor Company. Stuart had a room in the loft, which he used for his painting, and this was also where Astrid photographed Stuart, as well as the other Beatles. Stuart continued to paint during 1961 and early 1962, even though his headaches were gradually getting worse. Sadly, on 10 April 1962, Stuart collapsed in agony. Astrid called for an ambulance, but he died in her arms on the way to hospital. He was just 21. After Stuart died, John insisted that Astrid photograph him in exactly the same pose as she had done for Stuart.

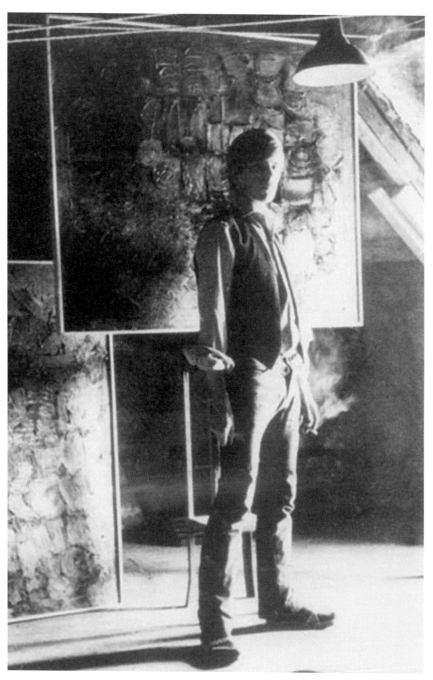

Stuart Sutcliffe in the loft of the Kirchherr family's Eimsbütteler Strasse home. Photograph by Astrid Kirchherr, Copyright Ginzburg Fine Arts.

Hotel Germania, Detlev-Bremer-Strasse 8

Hotel Germania was where Manfred Weissleder housed The Beatles during their trip to the Star Club, from 1–14 November 1962.

Hotel Pacific, Neuer Pferdemarkt 30

During The Beatles' final Star Club trip in December 1962, they were housed in this fine hotel on Neuer Pferdemarkt, as were all the Star Club musicians from this time on.

Hotel Safari, Grosse Freiheit 304

Just down Grosse Freiheit from the Kaiserkeller, and opposite the site of the Star Club, is the Hotel Safari. When The Beatles played at the Star Club in April 1962, Manfred Weissleder rented them rooms on the first floor of the Hotel Safari; no small upgrade in comparison to their first lodgings at the Bambi Kino just two years earlier.

Hotel Schloss Tremsbüttel

The Beatles stayed at this hotel on their return to Hamburg on the night of 26 June 1966. The 'Fairy Tale Castle' is situated between Hamburg and Lübeck and further highlights how far The Beatles had come in comparison to their first stay in Hamburg at the Bambi Kino. The current hotel was built in the 1890s but has a history dating back to the 1400s.

The hotel was used to having celebratory guests, as the Rolling Stones, Sophia Loren and Leonard Bernstein were also patrons. As soon as word got out about where The Beatles were staying, the press immediately started called the hotel 'Schloss Tremsbeatle' and the building was surrounded by fans. In the afternoon, they waved to their enthusiastic fans from the balcony of the castle, for exactly 44 seconds, as reported by the press!

RECORDING STUDIOS

Akustik Studio, Kirchenallee 57

In October 1960, Rory Storm and the Hurricanes joined The Beatles in Hamburg to play at the Kaiserkeller. Manager Allan Williams had joined his groups in Hamburg. While there, he asked the Hurricanes' bass player, Lou Walters, to make a record. Williams hired the Akustik Studio on the seventh floor of 57, Kirchenallee (also known as the Klockmann-House). Walters was a fine ballad singer, and Williams wanted to hear him on record. The studio was booked for 15 October 1960, and Walters was accompanied there by his bandmates Ty Brien, Johnny Guitar and Ringo Starr. Williams and Walters also invited John, Paul and George to the session to join him on the recording. Stuart Sutcliffe was busy with Astrid, whilst Pete Best wouldn't be required because Ringo was drumming; Pete went shopping for drumsticks instead. Rory Storm turned up later in the day.

Lou Walters later recalled in an interview that the three songs they recorded were 'Fever', 'September Song' and 'Summertime'. For the first two, the line-up was Walters on bass and vocals, Ty O'Brien on guitar, Johnny Guitar on lead guitar and Ringo on drums. For 'Summertime', John Lennon, Paul McCartney, George Harrison and Ringo Starr backed him; for the first time, John, Paul, George and Ringo appeared together on a record.

Deutsche Grammophon Gesellschaft, Alte Rabenstrasse 2

Brian Epstein was in Hamburg at the Deutsche Grammophon conference for three days from 24 April 1961. One of the men he met there was Bob Boast from HMV in London. When Brian later visited Boast in London with his demo of The Beatles, it led to Brian meeting with George Martin, who would become the group's celebrated producer.

Friedrich-Ebert-Halle, Alter Postweg 36, Harburg

Possibly the most important dates for The Beatles in Hamburg were the 22 and 23 June 1961. It was here, in the theatre located inside Friedrich-Ebert-Halle, that Bert Kaempfert recorded Tony Sheridan and his backing band The Beat Brothers, better known as The Beatles. Stuart had recently quit the group to concentrate on his art, so Paul had stepped in on bass guitar.

The record they made, 'My Bonnie', would be the foundation of their future career as recording artists. Their rocked-up version of the old Scottish folk song about Bonnie Prince Charlie was released on the Polydor label in Germany, and was a reasonable success in the charts there.

However, when The Beatles returned to Liverpool and started promoting the record, their fans were going into Brian Epstein's shop, NEMS, and asking for 'My Bonnie' by The Beatles. Brian tracked it down to Germany, and when he advertised them for sale, they sold out quickly. As a record retailer, Brian was interested in a Liverpool group who could sell records. He thought he should check them out, which he did, at The Cavern Club. He was so impressed with John, Paul, George and Pete Best, that he offered to become their manager, which was the start of their journey to the "toppermost of the poppermost".



'My Bonnie' was the record that was made in Hamburg, brought home to Liverpool, transported to London by Brian as proof of The Beatles' prowess as record-makers, and eventually had drums overdubbed in New York by Bernard Purdie. All this from an old Scottish folk song about a prince who escaped to France.



FAB FOUR CONNECTIONS

Studio Rahlstedt, Gebäude M1, Rahlau 128, Hamburg-Tonndorf

On 24 May 1962, and as a last contractual fulfilment for Polydor, The Beatles recorded the instrumental backing on two more old songs, 'Sweet Georgia Brown' and 'Swanee River'. Sheridan and Kaempfert had already recorded the songs, and released them on

an album called *My Bonnie*, including the title track and another song recorded the previous year called 'The Saints'. John, Paul, George and Pete were accompanied not by Sheridan, but by their new friend from the Star Club, Roy Young, a boogie-woogie piano player who was known as Britain's answer to Little Richard. George's guitar playing was not required, though he provided backing vocals. Pete provided his snare drum rhythm, just as he had done for 'My Bonnie'; Paul played bass; John played rhythm and Roy was on piano. The studio has since been demolished.

IMPORTANT HAMBURG CONCERTS

Indra Club, Grosse Freiheit 64

17 August 1960 – 3 October 1960

The Indra became the first Hamburg club to witness new band The Beatles, direct from Liverpool. The club had been opened by Bruno Koschmider back in 1950, and, having had success with Derry and the Seniors, also from Liverpool, Koschmider met with Allan Williams and asked him to send another group over. Williams, now acting as The Beatles' manager, chose them to go.

The Beatles' first appearance was on 17 August 1960; their new adventure had begun. The five-piece at that time comprised John, Paul, George, Stuart and Pete, and they would soon establish themselves as the top group in Hamburg. They were each on

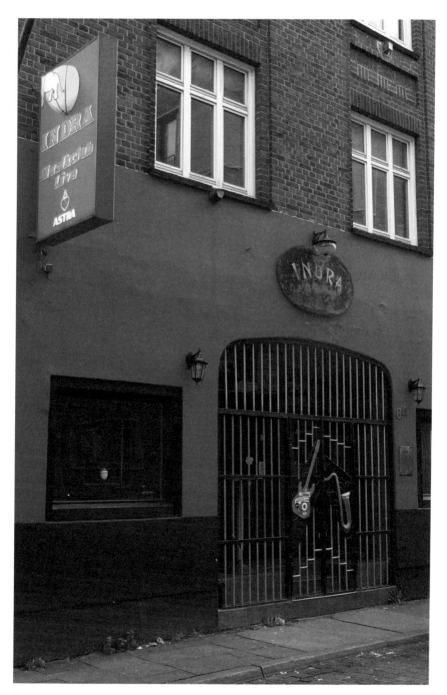

The Indra Club, the first venue The Beatles played in on arrival in Hamburg.

approximately £3 per day – 30 Deutschmarks – for which they were expected to perform for around five hours on weekdays, extended to six hours on Saturday. This was a great foundation for them, learning to play together and honing their stage skills, which went down well at the club, though the crowds were still quite sparse at times. After 48 nights, Koschmider decided that he should transfer The Beatles a few hundred yards up the Grosse Freiheit to his other club, the Kaiserkeller.

Kaiserkeller, Grosse Freiheit 36

4 October 1960 – 28 November 1960

Koschmider had only opened the Kaiserkeller in 1959, so the club was relatively new when The Beatles first played there. Tony Sheridan had left London for the Kaiserkeller in June 1960, followed by Liverpool's Derry and the Seniors. As The Beatles were bringing their time at the Indra to an end, another Liverpool group, Rory Storm and the Hurricanes, with Ringo on drums, had begun their first Hamburg stint at the Kaiserkeller on 1 October. It would mark the beginning of a friendship (for Ringo, in particular, with The Beatles) and rivalry between the two bands as to who would be crowned the kings of Liverpool in 1961.

The two groups alternated their time on stage, playing throughout the evening and into the night. The Kaiserkeller would also have an effect on several relationships. Klaus Voorman discovered The Beatles here and immediately told his close friends Jürgen Vollmer and Astrid Kirchherr about this incredible new group. Astrid would fall in love with Stuart, while Klaus, a talented artist, designed The Beatles' *Revolver* album cover and had a successful musical career of his own, playing bass with Manfred Mann and with John Lennon on his *Plastic Ono Band* album.

The Beatles firmly established themselves as a popular rock 'n' roll group at the Kaiserkeller, drawing the crowds in with their mixture of music and showmanship on stage. The legendary cry of "Mach Schau" by Koschmider told the group to up their performance. For John Lennon, this was his excuse to go a little mad! Fuelled by

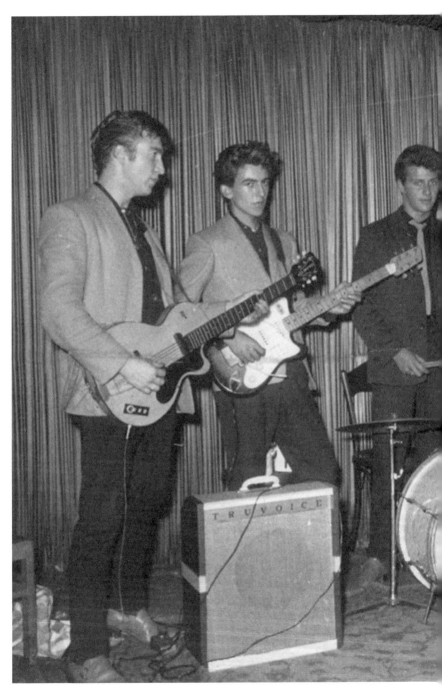

John, George, Pete, Paul and Stu ready to take to the stage at the Indra Club for the first time.

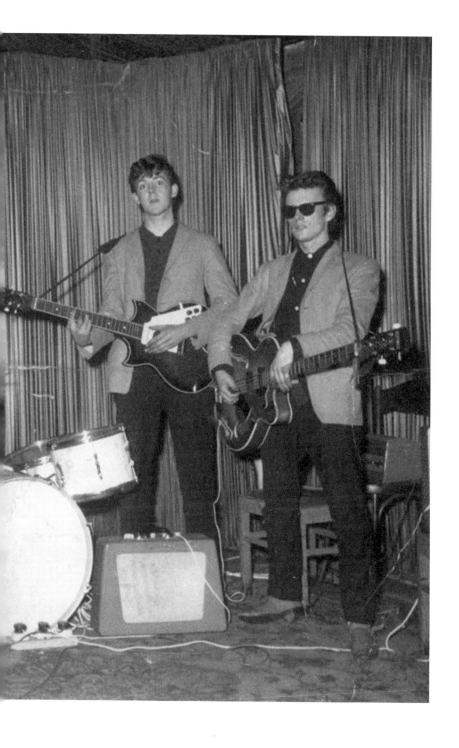

alcohol and Preludin tablets, Lennon led the new 'punk' Beatles into becoming great showmen, performing with a toilet seat around his neck, goose-stepping or shouting "Heil Hitler"!

The Kaiserkeller didn't have a very good stage, and so a scheme was plotted between the two resident Liverpool groups; could they break it? In the end it was Rory Storm who put his foot through the wooden stage first, infuriating Koschmider, who banned him from the club. What would anger Koschmider even more was when Peter Eckhorn, owner of the Top Ten Club around the corner on the Reeperbahn, approached The Beatles and offered them a new residency at his club. The Top Ten was a superior club, and a step up for them, but when the group told Koschmider they were moving, he was furious, and told them that they had signed a contract, and that they couldn't play elsewhere.

Koschmider informed The Beatles that he was terminating their contract. Worse than that, he reported George Harrison to the authorities, who arrested him for being under age – there was a curfew of 10pm for under eighteens, but he was still on stage in the early hours of the morning. Once arrested, George was deported on 21 November 1960. Koschmider then had Paul and Pete arrested for attempting to burn down the Bambi Kino (see page 69); they too were deported, on 5 December. John stayed for a few days, before heading home too. Stuart, already in love with Astrid, decided to remain in Hamburg. Was this the end for The Beatles?

Allan Williams had left Liverpool with Derry and the Seniors, travelling to London, where he met up again with Hamburg's Bruno Koschmider, who brought them to the Kaiserkeller in Hamburg. This opened the door for other bands from Liverpool, including The Beatles.

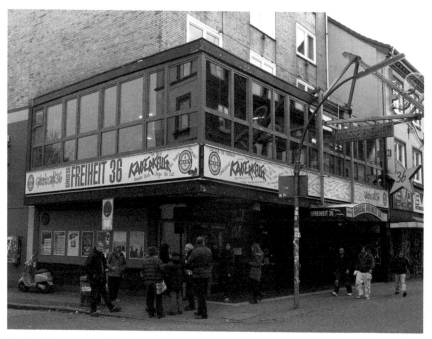

The Kaiserkeller, the second club where The Beatles played on the Grosse Freiheit.

The Beatles also played at Studio X, above the Kaiserkeller.

Studio X,
Kaiserkeller, Grosse
Freiheit 36

29 November 1960

Located on the top floor of the Kaiserkeller, Studio X was run by Uwe Fascher, brother of Beatles 'minder' Horst Fascher. After George was deported, John, Paul, Stuart and Pete played here for a few nights, before Pete and Paul were also deported.

Top Ten Club,
Reeperbahn 13

27 March 1961 –
1 July 1961

While The Beatles were in Hamburg, Horst Fascher encouraged a local businessman to open a club in the former Hippodrome. Peter Eckhorn decided to do what Koschmider was doing, only better, and in November 1960 he opened the Top Ten Club. When he approached The Beatles, they were impressed, and decided that it was worth the move for a better atmosphere and improved living and working conditions. However, when they left the Kaiserkeller, Koschmider took his revenge (see page 80).

When The Beatles were invited back to Hamburg, it was at the Top Ten Club that they would play. Eckhorn, along with Mona Best and Allan Williams, managed to assist with getting proper visas for The Beatles, so that this time they would be in the country legitimately. Paul and Pete had to send their letters of regret to the Chief of Police before they were allowed to return. And so it was that on 27 March 1961, they played the opening night of their latest Hamburg tour at the Top Ten for Peter Eckhorn.

The Top Ten Club soon started to take the crowds away from the Kaiserkeller, and became the club to be seen in. The Beatles were now becoming kings of Hamburg and Liverpool, and, with Tony Sheridan, attracted local music producer Bert Kaempfert to the club. Kaempfert decided he wanted to record Sheridan with The Beatles as his backing band. Those recordings would produce 'My Bonnie', the very first Beatles record, even though it was under the name of Tony Sheridan and the Beat Brothers. The Beatles left the Top Ten Club to return to Liverpool at the beginning of July 1961.

It was at the Top Ten Club that The Beatles first met Tony Sheridan, the rock 'n' roller from London's 2i's Coffee Bar who had first come over to Hamburg with Bruno Koschmider.

The relationship between Sheridan and The Beatles was crucial to their development. He taught them stagecraft, how to take a two-minute song and make it last for five, ten or even fifteen minutes. The Liverpool musicians all referred to Sheridan as 'The Teacher'. Sheridan and The Beatles shared rooms at the top of the building above the club, situated on the Reeperbahn, just around the corner from Grosse Freiheit.

Tony Sheridan is one man who links Liverpool, Hamburg, London and New York with The Beatles. Having started in London at the 2i's Bar, and then having spent time as a mentor to The Beatles in Hamburg, he was sent to Liverpool at the end of 1961 looking for bands. While there, he offered Ringo Starr the opportunity to leave Liverpool and join him in Hamburg. Ringo accepted the invitation, but only lasted a few weeks, as he was unable to get along with the erratic Sheridan. After The Beatles became famous, Sheridan was offered several opportunities to release updated versions of the songs he recorded with The Beatles. On 3 February 1964, just days before The Beatles landed at JFK Airport, *The Beatles with Tony Sheridan and Friends* was released in the US. The album was supplemented by six instrumental tracks by New York group Danny Davis and The Titans.

Star Club, Grosse Freiheit 39

13 April 1962 –
31 May 1962

In the same way that the Kaiserkeller had been eclipsed for The Beatles by the Top Ten Club, so the Top Ten itself was upstaged with the opening of another new club on Grosse Freiheit, in April 1962. The Star Club would go on to host some of the biggest names in rock 'n' roll music. Opened by Manfred Weissleder

Back in the UK, having returned to Liverpool from Hamburg in July 1961, Allan Williams, with whom The Beatles had fallen out, decided to open his own Top Ten Club in Soho Street, Liverpool (see page 38). However, the club burned down soon after opening, with Williams losing money. His idea had been to combine Soho – the heart of London's music scene – with the Top Ten, Hamburg's top club, in Liverpool, but it wasn't to be.

on 13 April, The Beatles were soon rocking the Star Club, often assisted on stage by pianist Roy Young, sometimes described as a white English Little Richard. His boogie-woogie piano style and incredible rock voice made him an instant hit. Young got on so well with The Beatles, both on and off-stage, that Brian Epstein offered him the chance to come back to Liverpool to join The Beatles. He turned the offer down.

The Star Club was played by some of the biggest names of the times: Little Richard, The Everly Brothers, Gene Vincent, Ray Charles and Jerry Lee Lewis. In 1962 The Beatles played at the Star Club on three occasions between 13 April and 31 May, and it was here that they received news of their EMI audition via a telegram from Brian Epstein. This would be Pete Best's last Hamburg tour with the group.

1 November 1962 – 14 November 1962, and 18 December 1962 – 1 January 1963

The Beatles returned to the Star Club in November, playing for two weeks, now with Ringo behind the drums. When they arrived for their final visit to the club on 18 December 1962, 'Love Me Do' was in the charts, and the group had moved on. However, at the end of their trip, Liverpool musician Ted 'Kingsize' Taylor, with the help of Adrian Barber, recorded The Beatles on stage, in what would

become the infamous 'Star Club Tapes'. Released several times, and blocked by The Beatles, it became a Beatles bootlegger's dream to own. They have been released on LP, and are now on general release on CD. George Harrison attended court personally to block their release, claiming that it was just one load of drunks recording another load of drunks. However, if you want a glimpse of what The Beatles sounded like live, before they had lost all of their rock 'n' roll, then they are well worth listening too.

The Star Club closed in 1969; the building burned down in 1983 and was demolished in 1987.

Ernst Merck Halle, Jungtusstrasse

26 June 1966

Having made their name in Hamburg during 1960-62, The Beatles returned there in 1966 as part of their 'Bravo Blitztournee' tour, playing two shows at the Ernst Merck Halle. Both shows took place on 26 June. They arrived at Hamburg's central train station soon after 6am, to be greeted by a hoard of screaming fans, and were taken to the grand Schloss Hotel in Tremsbüttel (see page 72), just outside the city.

At the concerts, The Beatles played only eleven songs, in a set that lasted barely thirty minutes. It was a far cry from the six-hour performances they had played in their early days in Hamburg. A press conference they gave between concerts is only notable for the mind-numbing questions the band were asked, and how bored they were answering them.

Forty-four people were arrested for rioting during the shows, both inside and outside the venue. The Beatles were visited by many of their old Hamburg friends, including Astrid Kirchherr and future husband Gibson Kemp. Astrid gave John Lennon a collection of letters he had written to Stuart Sutcliffe after The Beatles had returned to England without him. When John saw Bert Kaempfert, he sang the first line of 'Strangers in the Night' – the hit that Kaempfert had just written for Frank Sinatra.

OTHER BEATLES SITES IN HAMBURG

GROSSE FREIHEIT AND THE REEPERBAHN

Most of the Hamburg that The Beatles knew was around Grosse Freiheit and the Reeperbahn, although the harbour and the rest of the beautiful city also have much to offer the visitor. Running off the Reeperbahn, Gross Freiheit means 'Great Freedom'. Although many take this meaning as an allusion to the sexual services on offer, the 'freedom' actually dates back to the seventeenth century, and originally referred to the liberal attitudes of fair trade and religion without restriction. In the twentieth century it would, of course, become more renowned for the new freedom that The Beatles enjoyed away from home and the watchful eyes of their parents. Here, you could go to church, cafes and restaurants, clubs and bars, as well as live sex shows. No wonder The Beatles said they 'grew up' in Hamburg, and spent most of their time in this area.

Grosse Freiheit was so different to the red-light area The Beatles knew around Gambier Terrace in Liverpool, or the Soho area of London where the 2i's Bar was. In 1961, Brian Epstein was in Hamburg for a conference being hosted by Deutsche Grammophon. Held over three days from 24 to 27 April in Hamburg and Hannover, Brian would surely have found himself on the Grosse Freiheit; could he have wandered in to see The Beatles on stage?

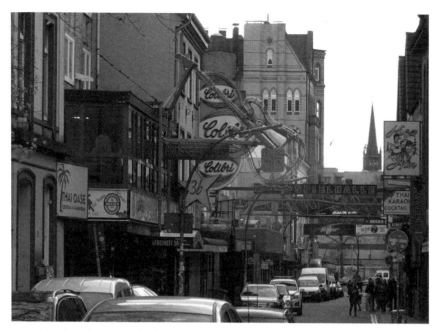

The Grosse Freiheit looks very different during the day. The Beatles would often find somewhere to eat here after performing.

Beatles Platz on the Reeperbahn, looking up Grosse Freiheit.

Hamburg, Liverpool and London all had their own 'rope-walks', where the Reeperschlagers (ropemakers) made their hemp ropes for ships, and which were essential to support the shipping trade. Just like the area around Duke Street in Liverpool, known as the 'rope walks' area, Hamburg needed a long straight road – the Reeperbahn – to lay out the ropes as they were being created.

Beatles-Platz

Although Hamburg hasn't cashed in on its Beatles heritage, at the bottom of Grosse Freiheit, where it meets the Reeperbahn, is Beatles-Platz. This tribute to The Beatles sees metallic silhouettes of the group, with Stuart Sutcliffe set slightly off to one side. It is set on what is meant to be a vinyl record.

Chum Yuen Poon, Schmuckstrasse 9

Historically, Hamburg's Chinatown was located in Schmuckstrasse, though many of its inhabitants were sent to a concentration camp by the Nazis during the war. After the war some of the restaurants opened up again and one of these, the Chum Yuen Poon, just off Grosse Freiheit near the Kaiserkeller, was a popular hangout for The Beatles and their fellow musicians. As in the ports of Liverpool, London and New York, Hamburg's Chinatown was a well-established part of the community.

Davidwache, Spielbudenplatz 31

It was here, in the local police station, that Paul and Pete spent a night in the cells after being arrested for attempted arson.

Der Lachende Vagabund, Grosse Freiheit 50

Der Lachende Vagabund was a bar located on the corner of Grosse Freiheit and Schmuckstrasse, opposite the Kaiserkeller, and was the workplace of The Beatles' friend and minder Horst

The police station where Paul and Pete were kept in a cell overnight.

Fascher after he fell out with Top Ten Club owner Peter Eckhorn. All of his musician friends, especially The Beatles, would call by to see him each day. Today, the location houses a restaurant.

Erdmann Lederbekleidung, Reeperbahn 155

When The Beatles' suits started to fall apart, they needed something more durable. The perfect solution lay in the leather shops of Hamburg, including this store where John, Paul, George and Pete purchased the black leather suits that would become the symbol of the 'Savage Young Beatles', until Brian Epstein returned them to more regular suits.

Grand Hotel Monopol, Reeperbahn 48-52

One evening, the legendary Gene Vincent, who was appearing at the Star Club, took Paul and George back to the Grand Hotel Monopol where he was staying. Vincent was well-known as a fan of guns, and soon picked himself up a handgun in Hamburg. Somebody told Vincent that tour manager Henriod was trying to seduce his wife back at the hotel, so, with George and Paul in tow, they headed back. When George was interviewed for *The Beatles Anthology*, he recalled how Vincent, desperate to get into his bedroom, handed George the gun. In a panic, George handed the gun back to Vincent, saying, quite politely, "no thank you, see you round, squire", and ran out of the hotel as quickly as he could. Today, the hotel is called the City Hotel Monopol.

Gretel & Alfons, Grosse Freiheit 29

One of The Beatles' favourite places to hang out on Grosse Freiheit was Gretal & Alfons, which opened in 1953. It was a popular cafe and restaurant, and is still there today. When Paul McCartney returned to Hamburg in 1989 for a Press Conference at the Kaiserkeller, he visited Gretel & Alfons and paid off his outstanding bar bill, with interest, as well as donating a signed poster too. The Beatles would also often eat next door at Grosse Freiheit 31, at the strangely named Fast Food Grannies, as well as at Sascha's at Grosse Freiheit 25.

Harald und Lore, Grosse Freiheit 15

One of the group's favourite breakfast establishments was Harald und Lore, where they could get their favourite cereal – Kellogg's Cornflakes – at any time of day.

Heiligengeistfeld, Hamburger Dom fairground

Some of the finest ever photographs of The Beatles were taken here by Astrid Kirchherr. She managed to capture the true essence of the rock 'n' roll Beatles from that period like no other. Mean and moody, shot in black and white with the travelling fairground behind them, these photographs of John, Paul, George, Stuart and Pete are almost as iconic as the band itself.

Brian invited Astrid to London and Liverpool to do photo shoots with The Beatles in 1964, to supplement the incredible images she had taken in Hamburg.

These were the new hard-living, hard-rocking, leather-clad Beatles that few people got to see or hear, and were John Lennon's favourite days as a Beatle. Heiligengeistfeld, just a ten-minute walk from Grosse Freiheit, hosts the Dom fairground in Hamburg every year, when the whole site comes alive.

Herbertstrasse

Just off the Reeperbahn is the small side street of Herbertstrasse, which was – and still is – home to prostitutes, sitting in the windows, offering their services. The Beatles, naturally, came here out of curiosity and more. Was this how they really 'grew up' in Hamburg? Although every major city has its own red-light area, none of the lads would have seen anything like this before in their lives. The street is screened off by large gates at either end.

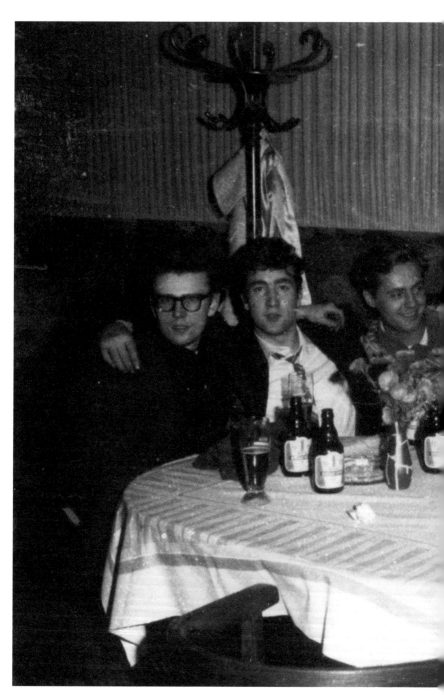

The Beatles with a waiter friend in 'Harald's'.

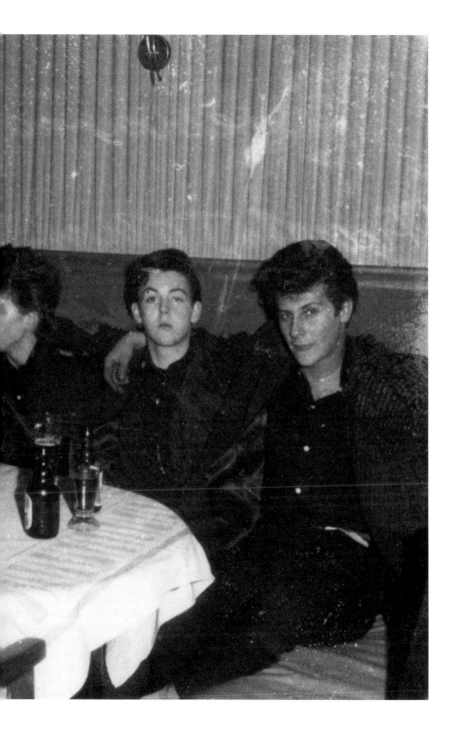

Jägerpassage 1, off Wohlwillstrasse 22

A short walk from Grosse Freiheit, one of the most iconic photographs from The Beatles' time in Hamburg was captured by Jürgen Vollmer in the doorway of 1, Jägerpassage. As John posed in the doorway, one leg across the other, Vollmer left his lens open to capture George, Paul and Stuart in blurred motion passing in front. The photograph was later used by Lennon, then resident in New York, as the cover for his *Rock 'n' Roll* album in 1975.

Panoptikum, Spielbudenplatz 3, Reeperbahn

Within this museum, you will see a remnant of the Star Club, where a section of the original stage has been preserved. Standing on top of the stage are waxworks of The Beatles.

Paradeishof, 27

Just off Grosse Freiheit were several little clubs and pubs that The Beatles would visit in their downtime, like the basement club Holle, which was open all night. There were also cafes such as Schlachterheinz and Flunder, and the oriental nightclub Salome.

Paul Hundertmark Jeans & Western Store, Spielbudenplatz

When The Beatles tried to settle on a new identity in Hamburg, they moved from suits to leather and, to complete the new look, purchased cowboy boots from this store on the Reeperbahn, proudly wearing them on the Top Ten Club roof.

St Joseph-Kirche, Grosse Freiheit 43

It seems strange that, amid the sex, rock 'n' roll and hedonistic excesses on offer, Grosse Freiheit is also the location of St Joseph's church, though maybe it is perfect for hearing confession! There was an allegation, investigated locally, that The Beatles desecrated the church; a letter from the prosecutors does exist, and questions were asked in 1965, though the matter was left unresolved.

The doorway in the Jägerpassage where John and The Beatles were photographed.

Salon Harry, Davidstrasse 23, opposite Davidwache Police Station

The story of The Beatles often seems to have revolved around their hair styles. From getting their hair cut as young lads at Bioletti's, Penny Lane, to Lesley Cavendish cutting it in style in London, and New York parents complaining of these Liverpool lads with long hair, Hamburg was also to play its part – with a bit of help from Paris too! In Hamburg, they kept their hair tidy here at Salon Harry. However, when Astrid cut Stuart Sutcliffe's hair into a more androgynous style, changing a rock 'n' roll quiff into a full fringe, the mop-top was born. Although initially they scoffed, when John and Paul later visited their Hamburg friend Jürgen Vollmer in Paris, they asked him to give them the same haircut. George had his hair done in a similar style a few weeks later.

Bäckerei Schumann, Paul-Roosen-Strasse 20

A favourite breakfast location for John, Paul, George, Stuart and Pete was the Schumann Bakery, just down the street from the Bambi Kino at the bottom of Grosse Freiheit.

HERE, THERE AND EVERYWHERE

Airport Fuhlsbüttel, Flughafenstrasse 1-3

Pete and Paul were taken to Airport Fuhlsbüttel on 5 December 1960 and sent back to Liverpool, following the allegations by Bruno Koschmider (see page 70). When John, Paul and Pete arrived at this airport to begin their stint at the Star Club in April 1962, they were greeted by Astrid, though not Stuart, whom they expected to see. Astrid had to break the sad news that Stuart had died. John went into hysterics before breaking down. He was devastated.

> The Beatles flew between Liverpool's Speke Airport and Hamburg several times.

The following day, Brian Epstein arrived, accompanied by George Harrison and Stuart's mother, Millie Sutcliffe. The Beatles were to make one last visit here in 1966, as they left after their 'Bravo Blitztournee' visit to Hamburg, when they took off for Japan.

Harvestehuder Weg/ Alte Rabenstrasse/ Aussenalster, Rotherbaum	Hamburg's little Alster steamers, just like the Mersey Ferries, ran up and down the River Elbe, and were often boarded by The Beatles. Jürgen Vollmer took some photos of George Harrison on the steamer, before heading back to the empty Top Ten Club and capturing some superb shots of The Beatles. From the landing stage at St. Pauli Landungsbrücken, you could catch the local ferry, 'cross the Elbe, and do a tour of Hamburg's harbour.
Hard Rock Cafe, Brücke 5, Bei den St. Pauli-Landungsbrücken	The Hamburg branch of this international chain of restaurants is located on the banks of the River Elbe in St Pauli, only a short walk from the Reeperbahn. It was opened by Ringo Starr on his seventy-first birthday, 7 July 2011, and included his now customary 'Peace and Love' celebration at 12 noon. Many items of Beatles memorabilia are on display throughout the restaurant.
Britische Seemannsmission (British Seaman's Mission), Johannisbollwerk 20 (Harbour)	In every major port visited by British seamen, you used to find a British Seaman's Mission. It was a taste of home; they served British food and had seamen there talking English! How reassuring that must have been for The Beatles and their fellow British musicians.

The location of the Britische Seemannsmission must have reminded the Liverpool musicians of home, as it was near the harbour, in the shadow of the overhead railway, just like the Liverpool Overhead Railway, which in turn was modelled on New York's elevated railway.

FAB FOUR CONNECTIONS

Fachhochschule für Gestaltung (Meisterschule für Mode, Werkschule für Textil, Grafik und Werbung), Armgartstrasse 24

The Beatles' first German friends, Astrid Kirchherr, Jürgen Vollmer and Klaus Voormann, all attended this school, formerly known as the School for Fashion, Textile, Graphics and Advertising. Astrid and Jurgen studied photography here under Reinhart Wolf, while Klaus studied graphic design. All three played important roles in shaping The Beatles, both in Hamburg and when they were famous. Astrid and Jürgen took some of the best photographs ever shot of the group, whereas Klaus's graphic design skills came to the fore when he provided the cover for the *Revolver* album, and much of the artwork for *The Beatles Anthology*.

Fischmarkt Altona, Grosse Elbstrasse

Like Liverpool, London and New York, Hamburg's port is very different today in comparison to the hustle and bustle of life here in the 1960s. The Beatles would often wander down to the harbour, just as they would back home in Liverpool. One of their favourite places to visit was the Fischmarkt, which was alive in the early morning, not long after The Beatles had finished playing. There is an apocryphal story that on one morning the lads decided to buy a pig here (it was more than just a fish market), which they named Bruno. The Beatles chased the poor pig around the site, bringing unwarranted attention from the local police. The story supposedly ended with poor Bruno providing bacon sandwiches for the hungry musicians not long after.

Hamburger Ledermoden, Poststrasse 33

Stuart Sutcliffe was known as "the James Dean of The Beatles", and he always managed to look so cool on stage. Being of similar stature, Astrid and Stuart would wear each other's clothes in an androgenous style, including a leather suit that Stuart had made here.

Hamburg Hauptbahnhof, Hachmannplatz 16

When George Harrison was deported from Hamburg on 21 November 1960, he boarded a train here and headed for Hoek van Holland. After crossing the North Sea by ferry, he made it home to Liverpool. George, along with his fellow Beatles, arrived back here

on 27 March 1961, before the band began their residency at the Top Ten Club. They returned to Liverpool from here on 3 July 1961.

Bert Kaempfert Produktion, Inselstrasse 4

Bert Kaempfert, as well as working for Polydor, had his own production company, based here. The Beatles and Tony Sheridan were signed to BKP through Kaempfert's publisher and lawyer, Alfred K. Schacht, on 12 May 1961.

FAB FOUR CONNECTIONS

> Bert Kaempfert recorded with Elvis Presley, Frank Sinatra and The Beatles. Brian Epstein contacted him from Liverpool to release The Beatles from their Polydor contract signed in Hamburg. As well as writing a song about New York, 'Look Me Up In New York', he was the first German band leader to be awarded a Gold record in the US, and picked up five BMI awards in New York too. In 1974, he performed at London's Royal Albert Hall.

Kemp's Bar, Mittelweg 27, Rotherbaum

Kemp's is an English-themed pub run by Gibson Kemp. A Liverpool drummer, he replaced Ringo in Rory Storm and the Hurricanes when Ringo joined The Beatles. After he left the Hurricanes, he joined Kingsize Taylor and the Dominoes, one of the biggest names in the Liverpool and Hamburg music scenes in the '60s. He was a regular at the Star Club, before forming a band called The Eyes, with Klaus Voormann. In 1965, he and Voormann joined Paddy Chambers, a former member of Liverpool band The Big Three, to form Paddy, Klaus and Gibson. Kemp's other Beatles connection was that he married Stuart Sutcliffe's former fiancée, Astrid Kirchherr, though the marriage only lasted around seven years. With second wife Tina, Gibson established Kemp's, a little piece of Liverpool and England in Hamburg.

Krameramts-wohnungen, Krayenkamp 10

Behind this ancient building, dating back to 1670, Stuart Sutcliffe posed for several photographs with his bass guitar in November 1960. Astrid Kirchherr captured shots of him on the steps with his guitar in its case, and also holding the instrument, uncased, in the passageway.

Leder Dschungel, Thadenstrasse 6

Another shop where The Beatles bought their leather jackets and trousers, having decided that leathers were the most practical clothes for their marathon sessions in the Hamburg clubs. When they returned to Liverpool, it was the leather-clad 'Savage Young Beatles' who took the city by storm. However, knowing that the leathers would have to go if the band were to make it outside Liverpool, Brian Epstein put them back in suits.

Musikhaus Rotthoff, Schanzenstrasse 71

Standing next door to the Hotel Pacific (a popular stay-over for visiting bands) is Musikhaus Rotthoff. Being next door to so many musicians must have made business fairly easy for this instrument shop. It was frequented by The Beatles as well as most of the other visiting groups.

Musikverlag Oktave, Heinrich-Barth-Strasse 13

This was the office of Bert Kaempfert's lawyer and music publisher. Kaempfert, who had recorded The Beatles with Tony Sheridan in June 1961, and published the records, was asked by Brian Epstein in Liverpool to release his group from the contract, which Kaempfert agreed to, after a final recording session. If this hadn't happened, Brian wouldn't have been able to sign his group to a new record company, Parlophone, in London. Thankfully, Kaempfert was very amenable.

Polydor, Harvestehuder Weg 1-4

This was the original location of Polydor Records, for whom Bert Kaempfert produced Tony Sheridan and the Beat Brothers with their famous June 1961 record *My Bonnie*. Polydor later moved to 31, Alte Rabenstrasse.

Spreehafen, Harburger Chaussee, Wilhelmsburg

In April 1961, Stuart Sutcliffe managed to talk John Lennon into inviting his girlfriend, Cynthia, to come and visit them in Hamburg. Cynthia brought her friend, and Paul's girlfriend, Dot Rhone, and they spent time together. One of their new Hamburg friends, Rosa, known as 'Mutti', a part-time cleaner at the Top Ten and provider of the 'prellies' that kept The Beatles going in the early hours, let Paul and Dot stay on her houseboat, harboured here at Spreehafen.

Steinway-Haus, Colonnaden 29

A popular music shop for the visiting musicians; John's iconic Rickenbacker guitar was purchased here, as was George's Gibson amplifier.

Staatliche Hochschule Für Bildende Künste (University of Fine Arts), Lerchenfeld 2

Stuart Sutcliffe, a talented artist, was offered the chance to study at Hamburg's University of Fine Arts under Eduardo Paolozzi in May 1961. Having received a scholarship, this decision quickened his exit from The Beatles so that he could concentrate on his first love – art. Stuart completed an incredible volume of work during his time there, which was, due to his tragic death in April 1962, less than a year. Paolozzi was the son of Italian immigrants. During the Second World War, he was interned – as most Italian men were – and then lost his father, uncle and grandfather when the ship they were travelling on to Canada was sunk by a German U-boat.

FAB FOUR CONNECTIONS

Eduardo Paolozzi had studied in Stuart's hometown of Edinburgh in Scotland, and was resident in Chelsea, London, when based at the Slade (where John Lennon's art-school life model June Furlong had been based). Paolozzi left Hamburg in 1962, moving to California and then returning to the Royal College of Art, London. One of his sculptures is situated at Pimlico Station in London. He was a huge fan of Stuart's artwork.

LONDON

1960

15 Aug ——————— The Beatles travel to London on the way to Hamburg

1961

10 Dec ——————— The group visit the Blue Gardenia Club after Aldershot

1962

1 Jan ——————— The Beatles audition for Decca
Feb ——————— Brian Epstein meets George Martin for the first time
June ——————— The Beatles first recording session with George Martin at EMI
4/11 Sept ——————— Recording 'Love Me Do' at EMI

1963

11 Feb ——————— Recording *Please Please Me* LP at EMI
13 Oct ——————— *Sunday Night at the London Palladium*
31 Oct ——————— Beatlemania at Heathrow Airport – Ed Sullivan's plane is delayed
4 Nov ——————— Royal Command Performance

1964

22 Feb ——————— Fly back from America to rapturous welcome at London Airport
2 March ——————— Begin filming *A Hard Day's Night*
6 July ——————— London Premiere of *A Hard Day's Night*

1965

March ——————— London-based filming of *Help*
26 Oct ——————— Receive MBE medals from HM Queen Elizabeth II at Buckingham Palace

1966

1 May ——————— Final scheduled Beatles concert appearance, at the NME Awards
Nov ——————— John meets Yoko Ono for the first time, at Indica Art Gallery
28 Nov ——————— The Beatles start the recording sessions that produce *Sgt. Pepper's Lonely Hearts Club Band*

1967

10 Feb ——————— Recording orchestral section of 'A Day in the Life'
25 June ——————— Beatles record "All You Need is Love" at EMI
27 Aug ——————— Brian Epstein dies at home in Chapel Street
11 Sept ——————— Commence filming on *Magical Mystery Tour*
5 Dec ——————— John and George attend a party for the opening of the Apple Shop

1968

July ——————— Apple Corps moves to 3 Savile Row
17 July ——————— Premiere of *Yellow Submarine* at the London Pavilion

1969

30 Jan ——————— Last ever live performance, on the roof of 3 Savile Row
12 March ——————— Paul McCartney marries Linda at Marylebone Register Office
8 Aug ——————— *Abbey Road* album cover shoot
22 Aug ——————— Last Beatles Photo session, at Tittenhurst Park

LONDON MAPS

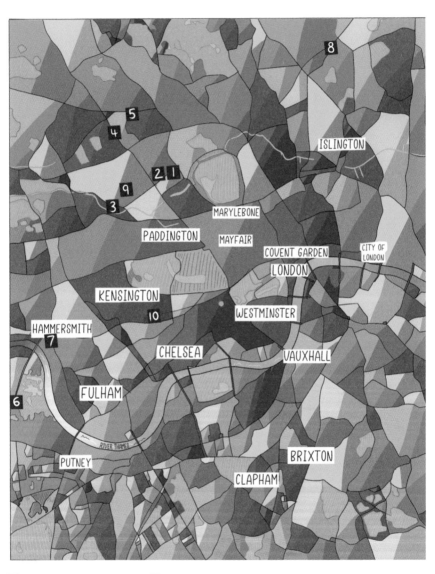

1. 7 CAVENDISH AVE
2. ABBEY ROAD STUDIOS
3. WESTMINSTER REGISTER OFFICE
4. GAUMONT STATE CINEMA
5. DECCA STUDIOS
6. OLYMPIC STUDIOS
7. HAMMERSMITH ODEON
8. ASTORIA, FINSBURY PARK
9. BBC MAIDA VALE
10. 13 EMPEROR'S GATE

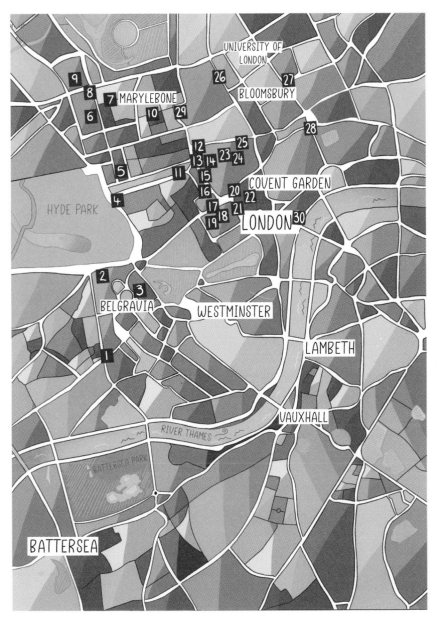

1. SLOANE SQUARE HOTEL
2. WHADDON HOUSE
3. 24 CHAPEL ST
4. GROSVENOR HOUSE HOTEL LONDON
5. 57 GREEN ST
6. 34 MONTAGU SQUARE
7. THE APPLE SHOP
8. THE OLD MARYLEBONE TOWN HALL
9. MARYLEBONE RAILWAY STATION
10. 57 WIMPOLE ST

11. CHAPPELL STUDIOS
12. PALLADIUM
13. NEMS ENTERPRISES & THE LONDON
14. CARNABY STREET
15. BAG O' NAILS CLUB
16. APPLE
17. PIGALLE CLUB
18. THE SCOTCH OF ST JAMES
19. INDICA ART GALLERY
20. THE LONDON PAVILLION

21. BBC PARIS STUDIOS
22. PRINCE OF WALES THEATRE
23. BLUE GARDENIA CLUB
24. TRIDENT STUDIOS
25. MPL
26. REGENT SOUND STUDIOS
27. PRESIDENT HOTEL
28. DE LANE LEA STUDIOS
29. BBC BROADCASTING HOUSE
30. PLAYHOUSE THEATRE

Beatlemania in full swing: Christmas Concert at the Astoria Cinema in Finsbury Park, London, December 1963. Sharok Hatami/Shutterstock.

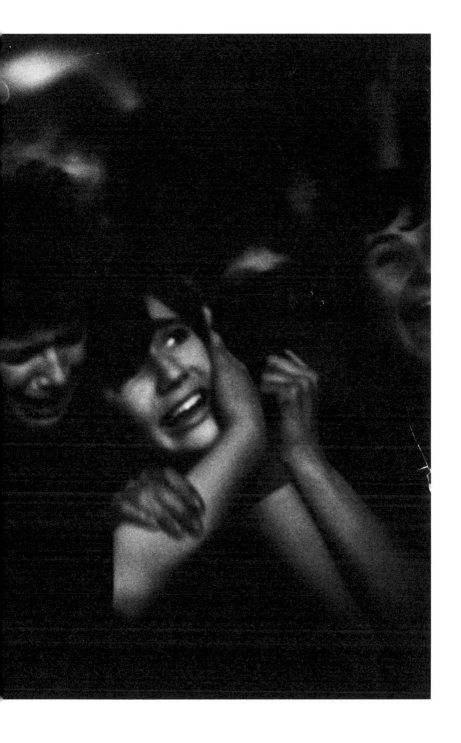

There is a well-known saying that "All roads lead to Rome" but for pre-Beatles popular music in England, all roads led to London. As the nation's capital, the city was the epicentre of its popular music industry, until The Beatles arrived there in 1963 and the 'Mersey Sound' was born.

Popular music in London was dominated by Denmark Street, known as London's 'Tin Pan Alley', nicknamed after a similar street in New York City. It was (and still is) only 60-metres long, but was full of songwriters, music publishers and recording studios. Much of the music press was based there too. The BBC had a legal monopoly of radio in the UK, and nearly all the music played on the airwaves came at least indirectly from Denmark Street. Added to this, showbusiness in the UK was dominated by the London-based Grade/Delfont family, who owned much of the independent TV franchise, theatres and music publishers.

Rock 'n' roll took longer to catch on in London than in Liverpool. Bill Haley had arrived from the US to great fanfare, but his performances left many disappointed. Although London had ten times the population of Liverpool, it only had a tenth of the number of rock 'n' roll venues and groups. The epicentre of the city's rock 'n' roll scene was the 2i's coffee bar in Soho. The 2i's started as a skiffle venue, with the Vipers as the house band in 1956, but transitioned to rock 'n' roll. Early rock and rollers who sang there included Cliff Richard and Tommy Steele, who – when they became stars – had their 'edge' taken away and were given Tin Pan Alley songs to sing, becoming all-round entertainers.

Although The Beatles never played at the 2i's, the venue plays a big role in their history. The top TV programme *Six-Five Special* produced a live show from the coffee bar, which inspired the Best family in Liverpool to open The Casbah Club for their children, which was where Tony Sheridan was discovered by Bruno Koschmider and taken to Hamburg, which in turn led to The Beatles travelling to Germany.

When Brian Epstein became The Beatles' manager, he realised straight away his main job was to secure the band a UK recording contract, and that meant traveling to London, where the vast majority of record companies were based. Surely, following their amazing success in Liverpool and Hamburg, it would be an easy job. However, Brian came up against the brick wall of the established London showbusiness elite.

Although Epstein had early success in obtaining The Beatles an audition with the massive Decca record label, they were turned down, as Decca man Mike Smith chose to sign local group Brian Poole and the Tremeloes, rather than a band from 200 miles away. The Beatles' luck finally changed thanks to a chance encounter for Brian in the HMV store on

Oxford Street, which in turn led to a meeting with George Martin, A&R man at Parlophone Records, part of EMI. Even then, George Martin apparently wasn't that impressed with Brian's recordings of The Beatles at first.

The Beatles' first single, 'Love Me Do', reached number 17 in the UK charts in October 1962 – with its strongest sales, not surprisingly, in Liverpool. The gamechanger was their second single, 'Please Please Me', which reached number one in some of the charts. It was at this point that Brian Epstein realised that The Beatles had to relocate to London. The music industry was based in London, and in those days, before the motorways were built, it was still an eight-hour drive between Liverpool and London – hardly conducive to a regular recording schedule. The Beatles didn't make their concert debut in London until April 1963 – and that was on a 'pop package' tour supposedly starring American artists Chris Montez and Tommy Roe. It soon became obvious that most people had booked to see The Beatles. The group's success paved the way for other Liverpool bands, such as Gerry and the Pacemakers and Billy J. Kramer and the Dakotas – also managed by Brian Epstein, who promoted many 'Mersey Beat Showcase' concerts in London. Now, record company talent scouts were traveling to Liverpool and signing pretty much anything that moved.

1963 was deemed 'The Year of The Beatles', and the term 'Beatlemania' was coined that autumn to describe the scenes at their concerts. They even appeared in front of the Royal Family. It was also the year that the UK had The Beatles almost to itself.

They were regularly seen in London nightclubs, and not only mixed with other musicians but also with actors, artists, photographers and models. They were at the epicentre of what became known as 'Swinging London'. Paul McCartney lived with the family of his London-born girlfriend, Jane Asher, and George Harrison married top London model Pattie Boyd. Even though Yoko Ono was based in New York, she and John Lennon first met in a London art gallery.

The Beatles also absorbed many influences from the London scene, incorporating them into their image and their music. Their magnum opus, *Sgt. Pepper's Lonely Hearts Club Band*, could only have been made in London. The city was also the base for Apple Corps.

The Beatles' partnership was finally dissolved in the London High Court – but the band still have a presence in London to this day. Although they also have offices in New York, both The Beatles' company, Apple, and Paul McCartney's MPL are still based in London, and Paul and Ringo still have homes there.

57 Green Street, the only home where The Beatles lived altogether.

John and Yoko lived in Ringo's Montagu Square flat for a short time.

Whaddon House, home to George, Ringo and Brian Epstein.

57 Wimpole Street, where Paul McCartney lived for three years.

FAB FOUR HOMES AND HOTELS

By 1963, The Beatles were spending more and more time in the London area and it became inevitable that they move away from Liverpool to be in the capital. Also, by then, the group had started having number one records, and could afford much better accommodation than the houses they were used to in Liverpool, and certainly better than the Bambi Kino in Hamburg! As and when their fortunes grew, and the hysteria of Beatlemania became too intrusive, they moved to the leafy Home Counties, albeit still within easy reach of London.

ALL TOGETHER

Royal Court Hotel, 8-10 Sloane Square, Chelsea

When The Beatles first came to London in June 1962, they all stayed together at the Royal Court Hotel. They travelled down from Liverpool to have their first recording session at EMI Studios. Three months later, they stayed at the Royal Court again, when they recorded their first single, 'Love Me Do'.

President Hotel, 56-60 Guilford St, Bloomsbury

In the summer of 1963, The Beatles moved into the President Hotel. While they were living there, Dezo Hoffman took many pictures to represent a day in the life of The Beatles, including a famous shot of them walking down the road just outside the hotel entrance in Guilford Street.

57 Green Street, Mayfair

After living in hotels, The Beatles moved into an apartment at 57 Green Street, Mayfair, around September 1963. However, they didn't stay there together for long – Paul moved to the Asher family home in Wimpole Street and John to Emperor's Gate with wife Cynthia and baby Julian. George and Ringo stayed in Green Street for a while longer, until they moved into Whaddon House, Williams Mews.

GEORGE AND RINGO

Whaddon House, Williams Mews, Knightsbridge

Brian Epstein had moved into Whaddon House in late 1963, and a few months later, when another apartment became available in the same block, he persuaded George and Ringo to move here, too.

RINGO STARR

34, Montagu Square, Marylebone

Ringo bought this two-bedroom apartment in the affluent Marylebone area of London as his first marital home with Maureen. Soon after moving in, Maureen gave birth to their first son, Zak. However, it wasn't long before Ringo and family decided to re-locate to the stockbroker belt and bought a house in Weybridge, close to where John and George were living.

'Sunny Heights' - South Road, St. George's Hill Estate, Weybridge

In 1965 Ringo, wife Maureen and their baby Zak moved into this large house very close to Kenwood, John and Cynthia's home.

In the house, Ringo built his own bar, which he called 'The Flying Cow'; there was a plaque of a specially designed cow, with wings hanging on some horns, just inside the door. Ringo would entertain his friends here. While at Sunny Heights, Ringo and Maureen had two more children, Lee and Jason. Ringo sold the house in 1969, when the family moved to Peter Sellers' old house in Elstead, Surrey.

JOHN LENNON

Flat 3, 13 Emperor's Gate, Brompton

John Lennon, wife Cynthia and son Julian lived here from November 1963 to July 1964. The flat was recommended to them by Robert Freeman, the renowned photographer, who took many of the pictures that appeared on The Beatles LP covers. John had an affair with Robert Freeman's wife, Sonny, and wrote a song about it – 'Norwegian Wood'.

During the period that the Lennons lived here, John was often away touring, leaving Cynthia to take care of baby Julian alone. Finally, John and Cyn decided to move out to a big house in Weybridge.

The block where John and Cynthia lived was demolished in the 1980s.

Kenwood, St. George's Hill, Weybridge

After leaving central London, John and Cynthia moved into a large house on the exclusive St. George's Hill Estate in July 1964. Although John only paid £20,000 for the property, he spent another £40,000 renovating it. The renovations went on for the first nine months the Lennons lived here, and in the end, they were forced to occupy the staff flat at the top of the house. During this time, it seemed like hundreds of workmen were forever in and out of the house, and John and Cyn were presented with designs for the house which were very beautiful but a long way from reality.

34, Montagu Square, Marylebone

In the spring of 1968, John broke up with wife Cynthia and started living with Yoko Ono. Before they found a place of their own, they lived in Ringo's flat. Ringo had moved out some time before but during the interim, the flat had been occupied by Jimi Hendrix and his manager, Chas Chandler.

Soon after moving into Montagu Square, John and Yoko posed naked in the apartment for photos to be used on their new *Two*

John at Kenwood, May 1968. Photograph by Marilyn Demmen.

George signing an autograph outside Kinfauns, wearing his famous 'Mad Day Out' T-shirt. Photograph by Marilyn Demmen.

Virgins album cover. Needless to say, the album cover caused considerable controversy.

John's drug conviction came back to haunt him when he and Yoko moved to New York. The Nixon administration used the conviction as an excuse to deport Lennon from America – as he was campaigning against the President in the 1972 Election.

John and Yoko were later raided by the police, who found a small quantity of marijuana, which John maintained wasn't his. It later emerged that the head of the police team, Sgt Norman Pilcher, had planted drugs in the apartment. Pilcher later served time in prison for perverting the course of justice. John pleaded guilty to the drugs charge, to keep Yoko out of it.

Tittenhurst Park, London Road, Sunningdale, Ascot

John Lennon bought this house with its majestic gardens in May 1969, and moved in with Yoko two months later, after renovations were carried out. They remained here for two years until they moved to the United States. On 22 August 1969, The Beatles came here for a photo session, mainly with Ethan Russell. It was to be their last formal photo session. Many pictures were taken in the grounds and by the house. A picture of The Beatles standing in a doorway was used on the *Hey Jude* compilation album.

John had a recording studio built in the house, and it was here that he recorded much of the *Imagine* album.

John sold the house to Ringo, who owned it until 1988. Ringo then sold the house to Sheikh Zayed bin Sultan Al Nahyan, then President of the United Arab Emirates and ruler of Abu Dhabi.

GEORGE HARRISON

Kinfauns, 16 Claremont Drive, Esher

George Harrison and wife Pattie lived here – a one-storey house on a private estate – from early 1965 to December 1969. In May 1968, The Beatles gathered at George's home studio at Kinfauns to record demos for songs that would be included on the 'White Album'. Some of the resulting demos can be heard on the fiftieth anniversary release of the album. On 12 March 1969, the same day Paul and Linda were married, Sgt Norman Pilcher, who had arrested John a few months earlier, arrived at Kinfauns to search the place for drugs. Only Pattie was in. She let the police search the house, and drugs were duly found. The police patiently waited with Pattie for George to come home before arresting them both.

PAUL McCARTNEY

57, Wimpole Street, Marylebone

Paul McCartney had first met Jane Asher at the Royal Albert Hall. Months later, Jane's family invited Paul to move into the family home in Marylebone.

Paul was given a room at the top of house at the back – it was almost a self-contained apartment with its own bathroom. He once compared it to an artist's garret. It had a bed, easy chair, record player and small piano.

Paul and John wrote 'I Want To Hold Your Hand' in Mrs Asher's music room in the basement.

Early one morning, Paul woke up in his Wimpole Street bedroom with a tune in his head. He went straight over to the piano he had by the bed, and payed the tune that he initially called 'Scrambled Eggs'. Eventually, Paul realised that he had dreamt the tune, and duly wrote some proper lyrics. He renamed it 'Yesterday'.

7, Cavendish Avenue, London, St John's Wood

Unlike the other Beatles, Paul McCartney decided to live in London after the group's fame grew. He originally bought this house in May 1965 for £40,000, but didn't move in until March 1966, after the alterations he ordered took much longer to complete than expected.

Paul initially lived here with Jane Asher, and was always being visited by friends, including Mick Jagger, Marianne Faithfull, John Dunbar, Robert Fraser, Brian Jones and many others. In 1968, Jane moved out after catching Paul with another woman. Then, a few months later, Paul's new girlfriend, Linda Eastman, moved in. They married on 12 March 1969.

All four Beatles regularly came to Cavendish Avenue before and after recording sessions at Abbey Road. Ringo even kept his drum kit here. It was here that a fan managed to get into the house through an open window upstairs – the bathroom window! Paul later wrote a song about it.

Paul had a glass summerhouse built in the garden, which he used for meditation, and in which he later installed a double bed. The Beatles were photographed in the summerhouse in 1968 during their marathon 'Mad Day Out' photo session.

BRIAN EPSTEIN

24, Chapel Street, Belgravia

Brian Epstein bought this house at the end of 1964. The Beatles came here on many occasions – most notably in May 1967 when Brian held a press party to celebrate the release of *Sgt. Pepper's Lonely Hearts Club Band*. One of the photographers at the party was Linda Eastman, who had met Paul for the first time just a few days earlier at the Bag O'Nails nightclub. DJ Kenny Everett later recalled that The Beatles were photographed against a huge fireplace and couldn't string a sentence together – they were all so stoned. Brian died in his Chapel Street house of an accidental drugs overdose, on 27 August 1967.

RECORDING STUDIOS

Decca Studios at 165 Broadhurst Gardens, West Hampstead in London

As soon as Brian Epstein became The Beatles' manager, he began writing to London-based record companies, and made several trips to the capital to meet with record company people. He soon got the group an audition with Decca Records. Decca's Mike Smith travelled to Liverpool to see the band play at the Cavern Club, and was impressed by their live sound. However, he also wanted to see them play in the recording studio, and so booked them an audition at the Decca Studios in West Hampstead for New Year's day in 1962. Despite Smith's enthusiasm after the audition, and the suggestion that a recording contract might be forthcoming, several weeks later Decca decided to turn The Beatles down – and signed London-based Brian Poole and the Tremeloes instead!

Abbey Road Studios, St John's Wood

EMI Studios opened on 12 November 1931, when Sir Edward Elgar conducted the London Symphony Orchestra playing his own composition, 'Land of Hope and Glory'. Since then, countless musical stars have passed through the studio's doors. During the early days, the official title for Abbey Road was EMI Studios; it didn't change its name until AFTER The Beatles album of the same name came out.

The Beatles first visited Abbey Road on 6 June 1962 for their audition with George Martin. After hearing them play several songs, George Martin gave the group a long lecture on recording techniques. He then apparently said, "Ok, I've had my say, now

you tell me if there is anything you don't like." After a short pause, George Harrison commented, "Well, for a start, I don't like your tie!" Fortunately, George Martin had a good sense of humour, and The Beatles passed their audition. The Beatles' first album, *Please Please Me*, was recorded on 11 February 1963 – in one day! Even though recording techniques were very basic in those days, creating an album in such a quick time was very unusual. In their early days, The Beatles fitted in recording sessions between concert tours, but that changed when the group gave up touring. Now they could spend as long in the studio as they liked. The landmark album *Sgt. Pepper's Lonely Hearts Club Band* duly took over four months to record. A very famous session took place at Abbey Road Studios on 25 June 1967, when The Beatles recorded 'All You Need is Love'. The event was broadcast live on an historic satellite TV show called *Our World*, with an estimated audience of 400 million people. The session took place in Studio One, the large brick building sticking out to the left of the studios as you look from the road. Studio Two, where The Beatles recorded most of their most famous songs, isn't visible from the front; it is behind the main building, and also sticks out behind the house to the right. The last Beatles song to be recorded at Abbey Road was 'I Me Mine', in January 1970. Since then, many Beatles projects have been carried out at the studios, including *The Beatles Anthology* DVDs and CDs, *The Live at the BBC* album and, more recently, the soundtrack to the Cirque Du Soleil show *Love*.

Regent Sound Studios 164-167, Tottenham Court Road

Although approximately 90 per cent of The Beatles' recordings were made at EMI Studios in Abbey Road, they sometimes used other London studios when EMI was already booked, or they wanted a change of scenery. The first such session was on 9 February 1967, when they came to Regent Sound to record 'Fixing a Hole' for the *Sgt. Pepper's* album.

According to George Martin, the studio was "very cramped and boxy" and The Beatles never went back.

THE ABBEY ROAD CROSSING

The Beatles posed on the Abbey Road zebra crossing on 8 August 1969. Abbey Road has never been the same since. Every day, fans from around the world come to the crossing to walk in the footsteps of their heroes and to see the studios where they recorded most of their songs.

Things could have been very different. Originally, the LP was going to be called Everest, after the favourite brand of cigarette smoked by Geoff Emerick, The Beatles' recording engineer. Someone had the bright idea that The Beatles should go to the mountain of the same name to shoot the album cover; The Beatles reaction to that idea can't be repeated here without offence! Finally, it was decided to call the album *Abbey Road*.

The idea for the picture was probably Paul McCartney's. A sketch drawn by Paul showing how the picture should look still exists. The photographer was Iain MacMillan, a long-time friend of John and Yoko. For the photo shoot, The Beatles congregated by the crossing at around 11.35am. This was an early start for them; their recording sessions didn't usually begin until around 2pm. The timing was deliberate, to ensure fans would not interrupt the photo session. The day was gloriously sunny, and Iain MacMillan stood on a stepladder in the middle of the road to get the required angle. The Beatles were asked to cross the road in procession, while MacMillan attempted to get the best shot. In the end six photographs were taken, and the whole session only took about ten minutes.

After the photo shoot, The Beatles had three hours to kill before they were due to start recording. In his personal diaries, Beatles PA and roadie Mal Evans noted that Paul, John and Ringo went to Paul's home nearby to relax, while George and Mal went to "Regents Park Zoo to meditate in the sun. To Krishna Temple for lunch and studio for 3pm". Since the famous Abbey Road picture was taken, several million people have crossed the street there, in imitation of their heroes.

Just after the album came out, the *Abbey Road* cover became the central part in a bizarre rumour and conspiracy theory that Paul McCartney was dead. Word went around that Paul had died in a car accident in 1966 and that The Beatles had replaced him with an imposter, to ensure their fame wasn't affected. However, the theory also proposed that The Beatles felt guilty about doing this, so they put 'clues' on various album covers and songs, revealing the truth. Many of these clues can apparently be found on the *Abbey Road* album cover. The rumour has refused to go away in the years since; indeed, there have been many books and TV shows on the subject. Paul himself lampooned the rumour on his 1993 album *Paul is Live*.

De Lane Lea Studios Kingsway

The Beatles came here on 25 and 26 May 1967 to record George Harrison's song 'It's All Too Much' for their forthcoming film *Yellow Submarine*. As the studio wasn't owned by EMI, none of the usual personnel like George Martin or Geoff Emerick from EMI Studios could accompany them, and it seems The Beatles produced the session themselves – which probably explains the rather chaotic recording!

Olympic Studios, Church Road, Barnes

Olympic is perhaps the second most famous studios in London. The Beatles came here in May 1967 to record 'Baby, You're a Rich Man', and again in May 1969 when they recorded parts of 'Something' and 'You Never Give Me Your Money'.

Olympic was extensively used by the Rolling Stones and in 1967 John and Paul came here to sing backing vocals on the Stones' single 'We Love You'.

Olympic was an independent studio in the 1960s, and later became part of the EMI studios group. It recently closed down, with EMI concentrating on Abbey Road Studios for all their recording requirements.

Trident Studios, 17 St. Anne's Court, Soho

The Trident Studios was set up by brothers Barry and Norman Sheffield in 1967. Its laid back atmosphere was an antidote to traditional studios like Abbey Road, where the engineers walked around in white coats. Also, Trident was the engineering pioneer of its day – they were the first in the UK to use Dolby and install an eight-track recording system. The conservative Abbey Road engineers would spend months on testing new equipment before it was used for recording, but at Trident it was used as soon as they could plug it in!

The Beatles first came here on 31 July 1968 to record 'Hey Jude'. Later, they recorded 'Dear Prudence', 'Honey Pie', 'Savoy Truffle' and 'Martha My Dear' at Trident for the *White Album*; and 'I Want You (She's So Heavy)' for *Abbey Road*.

Chappell Studios, 52 Maddox Street, Mayfair

Chappell Studios was an offshoot of the famous music store and music publishing company. The Beatles recorded 'You Mother Should Know' here on 22 and 23 August 1967, for their TV film *Magical Mystery Tour*.

By this time, Brian Epstein was an irregular visitor to Beatles recording sessions, but he did visit for a short time on the 23 August, just four days before he died at his home in Chapel Street, Belgravia.

BBC Studios, various locations

The Beatles recognised the importance of radio, and between 1962 and 1965 made over 50 broadcasts of songs recorded in BBC Studios, mostly in London.

In 1994, some of these recordings were released on the *Beatles, Live at the BBC* album, followed by *Volume 2* in 2013.

The cover of *Volume 1* shows The Beatles outside the **'Paris Studios'** at 12, Lower Regent Street.

Other BBC sessions took place at **BBC Maida Vale Studios**, Delaware Road; **BBC Broadcasting House**, Portland Place, Marylebone; and the **Playhouse Theatre**, Northumberland Avenue, Embankment.

IMPORTANT LONDON CONCERTS

Surprisingly, The Beatles didn't give their first London concert until March 1963; Brian Epstein didn't want them to play in the capital until they were 'established'.

Most of the concerts they played in London were in suburban cinemas on pop 'package tours' that snaked up and down the UK in the early to mid '60s. Most of these shows had around four or five musical acts, with a comedian as a compère between them.

Even as the headline act, The Beatles were only on stage for around 30 minutes per show – in stark contrast to the several hours a night they played in Hamburg.

On the first concerts they played in London, they were down the bill to American stars Chris Montez and Tommy Roe, but as the tour progressed, fan reaction to The Beatles grew and they were promoted up the bill.

It was in these early months of 1963 that fans started screaming at Beatles concerts, as reported in the local press. Only after The Beatles appeared on the TV show *Sunday Night at the London Palladium* did the phenomenon known as 'Beatlemania' became public knowledge and front-page news.

Granada Cinema, East Ham

9 March 1963

The Granada Cinema in Barking Road, East Ham, was typical of the Art Deco Cinemas around London that hosted pop concerts. During most of the week it would show the latest films, but occasionally it would act as a music venue.

For their first 'official' Beatles concert in London, the group sang 'Love Me Do', 'Misery', 'A Taste of Honey', 'Do You Want to Know a Secret', 'Please Please Me' and' I Saw Her Standing There' – their set lasting barely 15 to 20 minutes.

Despite hosting many great concerts in the '60s, when demand for its cinema dropped, the Granada became a Bingo club.

The building is now a Flip Out trampoline arena.

ABC Cinema, Romford

20 March 1963

Also on the Chris Montez/Tommy Roe tour, the ABC was just a couple of minutes' walk around the corner from George Street, home to Ringo Starr's step-grandparents, James and Louisa Graves, who, according to rumours, The Beatles visited after their gig. The ABC closed in 1999 and was later demolished to make way for Gibson Court, a housing development.

Swimming Baths, Leyton

8 April 1963

The Beatles' first London show as headliners. By day the venue was a swimming baths, but for concerts they would put boards over the pool and it would become like a ballroom. The boards would bounce up and down as the fans danced.

The Beatles' concert took place on the day that Cynthia gave birth to Julian. John would not see his first born for another three days.

Royal Albert Hall

18 April 1963

The Beatles' first appearance at this historic venue saw them top the bill on a show called *Swinging Sound 63*, hosted by BBC Radio. In the audience was young actress Jane Asher, who was

doing a photographic assignment for the *Radio Times*, the BBC's listings magazine. Jane sat in the audience as a reporter whilst a photographer recorded her reactions to the many groups on the bill. She started screaming when The Beatles came on.

After the show, Jane met The Beatles backstage and later joined them back at their hotel. It was that night that she started her five-year relationship with Paul McCartney.

Also present at the Albert Hall that night were the Rolling Stones. The Beatles had heard of the Stones' growing reputation, and had recently gone to the Crawdaddy Club in Station Road, Richmond, where the Stones had a residency. When Mick Jagger gave his speech inducting The Beatles into the Rock and Roll Hall of Fame in the 1980s, he remembered The Beatles had all worn long leather trench coats to the Crawdaddy, which had impressed him very much.

After the gig in Richmond, the Stones asked The Beatles back to their apartment in Edith Grove, Chelsea, for a party. In turn, The Beatles also gave the Stones tickets and backstage access for the Albert Hall gig.

Empire Pool, Empire Way, Wembley
21 April 1963

The Beatles played here on four occasions for the annual New Musical Express Poll Winners shows. Their performance in 1963 was their biggest concert to date. The 1964, 1965 and 1966 shows were all televised.

Pigalle Club, Piccadilly
21 April 1963

The Beatles went from the NME Poll Winners show to play a very rare nightclub gig in London, which was advertised only in *The Jewish Chronicle*.

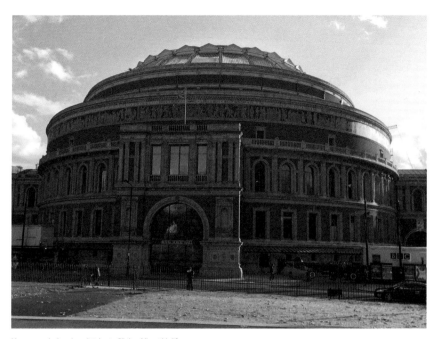

How many holes does it take to fill the Albert Hall?

Majestic Ballroom, Finsbury park, site of the Mersey Beat Showcase from 1963.

Majestic Ballroom, Finsbury Park

24 April 1963

Liverpool moves to London! A 'Mersey Beat Showcase', put on by Brian Epstein. Apart from The Beatles, the other acts on the bill were Gerry and the Pacemakers, The Big Three, and Billy J. Kramer and the Dakotas – all from Liverpool.

The Majestic Ballroom was owned by Top Rank, who ran a very similar ballroom in Birkenhead, on the Wirral, where The Beatles played many times.

Granada Cinema, Walthamstow

24 May 1963

The year wasn't yet half over when The Beatles embarked on their third national tour of 1963, this time with Roy Orbison. In March 2019, the derelict Grade II listed-Granada Cinema building was bought by Waltham Forest Council, who announced plans to restore its former glory.

Odeon Cinema, Romford

16 June 1963

Another Mersey Beat Showcase; the headliners – The Beatles, Billy J. Kramer and Gerry and the Pacemakers – were numbers 1, 2 and 3 in the British singles chart in the week of the concert!

Royal Albert Hall

15 September 1963

This was another 'Great Pop Prom' from the BBC, but this time The Rolling Stones were also on the show, and not carrying The Beatles' guitars. It was the first time The Beatles and the Stones had appeared on the same bill.

Prince of Wales Theatre

4 November 1963

In 1963, this theatre was the venue for the Royal Command Performance, an annual charity occasion with at least one member of the Royal Family in attendance. In front of HM Queen Elizabeth The Queen Mother and Princess Margaret, John Lennon asked for some help for their final number of the evening: "For the people in the cheaper seats, clap your hands. And the rest of you, if you'd just rattle your jewellery." Fortunately, John's cheeky comment was well received by the press, and the royals.

Prior to the Royal Command Performance, The Beatles had just flown back from a short trip to Sweden. They were welcomed at Heathrow Airport by thousands of screaming Beatles fans, causing many flight delays. One of those flights was to New York, on which a passenger, Ed Sullivan, witnessed Beatlemania for the first time. Three months later, the group's appearance on Sullivan's TV show unleased the phenomenon on the USA.

Ballroom, Grosvenor House Hotel, Mayfair

2 December 1963

On the same day that The Beatles taped an appearance on the *Morecombe and Wise Show* for TV, they played a cabaret-style floor show at this very high-class hotel ballroom, in aid of charity. The audience were all in evening wear, in stark contrast to the fans at the Cavern Club, where the band had given their last show just a few months before.

The Beatles' appearance at the show can probably be explained by Brian Epstein being resident in the hotel at the time.

Wimbledon Palais, Merton

14 December 1963

The concert was billed as the 'Southern Area Fan Club Convention' of The Beatles Fan Club. For the first part of the day, The Beatles sat behind the bar of the Palais as all of the 3000 fans present filed past to shake their hands and get autographs. Most of the fans were well behaved, but some started screaming when meeting their heroes became too much.

After everyone had filed past, The Beatles were to play a concert, but were amazed and angry when they saw they had to play in a huge steel cage – similar to those used to protect audiences from wild animals. The Beatles themselves were outraged at the thought of playing in a cage, especially in front of their most loyal fans, some of whom had travelled over 100 miles for the event. In

the end, though, The Beatles agreed to go on after apologising to the audience, and the show finished without incident.

Astoria Cinema, Finsbury Park

24 December 1963 – 11 January 1964

The Beatles held their 1963 Christmas show at this 3000 capacity cinema-cum-music venue, with more than 100,000 people seeing the 30 sell-out shows.

The show also featured many of Brian Epstein's other acts, such as Billy J. Kramer, Cilla Black and The Fourmost. The MC was Rolf Harris. Brian wanted it to be very different to the normal 'pop package' tours, creating a theatrical atmosphere with a mixture of comedy and lots of laughter, as well as songs. The Beatles also appeared in a Victorian-type melodrama scripted by Peter Yolland, producer of the show. The Beatles mainly performed songs from their new album, *With The Beatles*, plus favourites like 'Twist and Shout' and 'She Loves You'.

Gaumont State Cinema, Kilburn

23 October 1964

By the end of 1964, The Beatles' popularity was worldwide, and they spent much of the year abroad. For that reason, they only did one 1964 tour of the UK, and very few London concerts.

Odeon Cinema, Hammersmith

24 December 1964 – 16 January 1965

The Beatles returned to Hammersmith in December 1964 for 'Another Beatles Christmas Show'. They performed here for 20 days, averaging two performances a day (there were 38 performances in total). The format for the show was the same mix of music, comedy and pantomime as in the previous year. Also on the bill were Elkie Brooks, who became a big star in the 1970s, and the Yardbirds featuring Eric Clapton.

Site of the former Astoria Cinema where The Beatles performed their Christmas Show of 1963.

The Kiburn 'State', so called because of its resemblance to the Empire State building in New York.

Empire Pool, Wembley

1 May 1966

The Beatles' last ever scheduled live appearance in the UK was for the New Musical Express Poll Winners show in 1966, on the same bill as the Rolling Stones, The Who, the Small Faces, the Yardbirds and many others. Although the show was televised, the cameras were switched off for The Beatles' performance, due to a contractual dispute.

OTHER BEATLES SITES IN LONDON

SOHO AND MAYFAIR

Blue Gardenia Club, Wardour Mews

When The Beatles finished their first gig in southern England on 9 December 1961, at the Aldershot Palais, they didn't fancy the long drive back to Liverpool through the night, and so ventured into central London instead. According to agent Sam Leach, the band remembered that an old friend of theirs, Brian Cassar, of Cass and the Cassanovas, had moved from Liverpool to London and was involved in a club called the Blue Gardenia. It was in Wardour Mews, Soho, residing down a grubby back street alongside several other illegal, unregistered establishments. The owner of the club was Harry Bidney, leader of an anti-fascist group, and his club – and the street – was a meeting place for gay people, prostitutes and gangsters. It was the sort of club Brian Epstein would frequent on his many trips to London. Earlier in 1961, a big hole had been blown in the club's door by a cocoa-tin bomb, thrown by a customer who was refused entry.

The Blue Gardenia Club was also a hangout for musicians. Guitar hero Albert Lee was in the house band of the 2i's Coffee Bar, and remembers that when the 2i's closed for the night, he and the band's drummer, Jimmie Nicol, would go to the Blue Gardenia and play until the early hours. The recollections of what happened when The Beatles showed up at the club in late 1961 are vague, but it's believed that some of the group got up onstage with the house band and sang a few songs.

MPL
1 Soho Square

Located in Soho Square, these are the offices of Paul McCartney's company. MPL stands for McCartney Productions Ltd – NOT McCartney Paul and Linda, as some will have you believe. Paul visits here on a regular basis.

Carnaby Street

The shopping street that was the heart of 'Swinging London' in the 1960s. Carnaby Street became famous for Mods buying their clothes here and, later, for its rock-star clientele, including The Beatles.

London Palladium, Argyll Street

Located in Argyll Street, this famous theatre, which opened in 1910, was the venue of the TV show *Val Parnell's Sunday Night at the London Palladium*. It was a variety show that included dancers, comedians, acrobats and usually one artist appealing to teenagers.

The Beatles first appeared on the show on 13 October 1963. They had been on many teenage pop TV shows before, but this was their first time on a 'family' show, giving them exposure to adults as well as their kids.

Beatles fans kept vigil outside the theatre for most of the day, and those inside screamed at The Beatles when they were onstage. This reaction to the group had been happening nationwide, but the national press hadn't written about it. However, the next day, The Beatles and their fans were front page news in nearly every British newspaper. Their lives would never be the same again.

Many American stars played at the London Palladium, including Buddy Holly, Frank Sinatra, Dean Martin and Sammy Davis Jnr. Buddy Holly played the Palladium on his 1958 UK tour, as well as the Philharmonic Hall in Liverpool, on 20 March, with John Lennon in the audience.

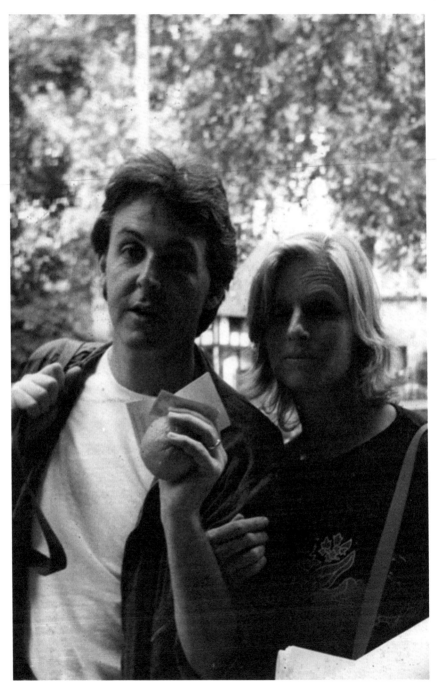

Paul and Linda McCartney outside MPL, 1983.

Brian Epstein's Office, Sutherland House, Argyll Street

Located right next door to the London Palladium, Brian moved NEMS (see page 43) from Liverpool to Sutherland House on 9 March 1964. The Beatles visited regularly, to see Brian and to meet members of the press. In 1966, John Lennon was interviewed here by Maureen Cleave of the *London Evening Standard* newspaper, in which the state of religion came up. Falling church attendances amongst young people made John suggest that The Beatles were more popular than Jesus Christ. Although the comment hardly raised an eyebrow in the UK, it led to burnings of Beatles records in the southern states of the USA, just before the Beatles were due to arrive for what became their last American tour.

Many of Brian Epstein's Liverpool staff relocated to London with him, including Alistair Taylor and Tony Bramwell.

In November 1966, John attended an exhibition at the Indica Art Gallery by New York based artist Yoko Ono.

Indica Art Gallery and Scotch of St James, (both) Masons Yard

'The Scotch' was another nightclub popular with The Beatles and other rock stars. It was here that Paul McCartney met Stevie Wonder for the first time. Three other patrons were Barry Miles, Peter Asher and John Dunbar, who were looking for premises for their new art gallery and book shop. They noticed that number 6 Mason's Yard, in the same courtyard as the Scotch, was available and was the perfect place. They named their new venture 'Indica' – after their favourite brand of marijuana! Paul McCartney and John Lennon were regular visitors to the gallery.

Bag O Nails Club, Kingly Street

In Kingly Street, which runs parallel to Carnaby Street, 'the Bag' was a regular hang-out for pop stars, including The Beatles, who liked that the club was open nearly all night. They could go there after late-night recording sessions at Abbey Road.

In the 1960s, Carnaby Street became famous for its Mod shoppers and, later, for its rock star clientele, including The Beatles.

The London Palladium, where The Beatles were introduced to a 'grown up' TV audience for the first time.

The site of the Bag O Nails Club, Soho.

Savile Row, site of The Beatles' final live appearance, on the roof.

Paul McCartney, the most regular visitor, was in the club on 15 May 1967 with a few friends to see Georgie Fame and the Blue Flames. Also in the club that night was New York photographer Linda Eastman, who was in London to photograph pop stars. Paul and Linda spied each other across the club and started talking.

Apple Corps HQ, Savile Row

In 1968, The Beatles purchased 3 Savile Row, in a street known the world over for tailoring. By then the group's Apple Corps business had developed into many different divisions, including records, film and electronics; there was even discussion on the idea of opening an Apple school. Unfortunately, The Beatles over-reached themselves and the company was run in a very laid-back manner – the food and drinks bill came to thousands of pounds each month. Richard DiLillo, a former employee of Apple, wrote a book about it called *The Longest Cocktail Party* (Playboy Press, 1972). DiLillo had the unofficial job title of 'house hippie'!

The basement of 3 Savile Row housed the Apple Studio, where The Beatles recorded much of what became *Let it Be*. They were filmed making the album, for what was going to be a TV documentary.

The recording sessions here certainly went better than at Twickenham, where the filming started. However, the film didn't have a climax, and Paul McCartney was determined to play live somewhere. It was decided that they would play a few songs on the roof of their own building on 30 January 1969.

Even though they couldn't be seen from the street, The Beatles could be heard for miles around and lots of people started gathering in the street below. Local tailors were not amused about their business being disrupted by the concert, and they called the police to get The Beatles to stop. With the nearest police station, West End Central, only 150 yards from 3 Savile Row, at the other end of the street, the police duly arrived. However, they did nothing, apart from directing traffic. This was actually a disappointment to The Beatles,

who wanted to be arrested to provide a great climax to the film. After finishing their final song, 'Get Back', the 'rooftop session' ended when John came to the microphone and said, "I'd like to thank you on behalf of the group and ourselves and I hope we passed the audition." It was to be The Beatles' last ever live performance.

Unfortunately, the financial disaster that Apple became led to The Beatles' eventual break-up. Apple became a virtually dormant company and the office section moved out of Savile Row in 1972, though the studios remained here longer. The Beatles finally sold 3 Savile Row in the late 1970s.



FAB FOUR CONNECTIONS

Many of the Apple staff had been with The Beatles from the early days in Liverpool, including Alistair Taylor, Peter Brown and Tony Bramwell.

To help save Apple, and themselves, from financial ruin, The Beatles brought in advisors from New York. However, they couldn't agree who was best. John, George and Ringo wanted Allen Klein, while Paul wanted his new in-laws, Lee and John Eastman. Klein and the Eastmans didn't get on, and the rift that developed in The Beatles was ultimately a major contributing factor in the group's break-up.



London Pavilion, Shaftsbury Avenue

This was the cinema where four Beatles films – *A Hard Day's Night*, *Help!*, *Yellow Submarine* and *Let it Be* – had their London premieres. On each occasion, Beatles fans brought Piccadilly Circus to a standstill, causing some of the most extreme cases of Beatlemania in the capital.

LONDON PAVILION PICCADILLY CIRCUS

ROYAL WORLD PREMIERE
in the gracious presence of
HER ROYAL HIGHNESS THE PRINCESS MARGARET and THE EARL OF SNOWDON
to aid THE DOCKLAND SETTLEMENTS and THE VARIETY CLUB HEART FUND

on **MONDAY, 6th JULY 1964** at **8.30 p.m.** (DOORS OPEN 7.30. SEATS MUST BE TAKEN BY 8.20 p.m.)

RINGO STARR GEORGE HARRISON PAUL McCARTNEY JOHN LENNON

THE BEATLES
IN **"A Hard Day's Night"**

WILFRID BRAMBELL NORMAN ROSSINGTON Directed by RICHARD LESTER Produced by WALTER SHENSON Screenplay by ALUN OWEN

DRESS CIRCLE ROW A SEAT No. 33 15 gns.
MAIN ENTRANCE PICCADILLY CIRCUS

A coveted ticket to the premiere of The Beatles' first feature film, *A Hard Day's Night*.

Marylebone Station played a supporting role in the film.

MARYLEBONE

Marylebone Station

This very attractive railway station was where the opening scenes of The Beatles first film, *A Hard Day's Night*, were shot.

In the film's first scenes, The Beatles run down Boston Place, the street by the side of the station, being followed by all their fans. They run around into the station itself and get on a train before they are besieged.

'Apple' Shop, Baker Street

The Apple shop was on Baker Street, famous as the home of Sherlock Holmes. It was the first of The Beatles' major Apple projects.

The band invited their friends – a group of designers from Holland known as 'The Fool' – to open a clothes shop with hippy accessories.

In the film *A Hard Day's Night* it is implied that The Beatles are travelling from Liverpool to London on a train, when actually both their departure and arrival were filmed at Marylebone.

The staff at the boutique, led by Jenny Boyd (Pattie Harrison's sister and the inspiration behind Donovan's song 'Jennifer Juniper') and Pete Shotton, John's old friend from Quarry Bank School, were young and inexperienced.

On the outside wall of the shop, The Fool painted a huge multi-coloured mural, which wasn't popular with local shop owners. They also didn't have planning permission and the local council demanded that the mural be removed, or they would do it themselves – and send the bill to Apple! The mural was duly whitewashed over.

The shop was launched with a huge opening party on 7 December 1967, attended by hundreds of 'beautiful people', but not, bizarrely, half of The Beatles. Only John and George went along. Everyone was given apple juice to toast the opening of The Beatles' new venture.

Unfortunately, the shop was not a success. Even though the clothes were certainly psychedelic and very much of their time, they were not well produced and were liable to fall apart rather quickly.

Only eight months after opening, The Beatles got fed up with the shop and closed it down. On the last day, the doors were left open, and anyone could come in and take what they liked without paying for it. People had been doing this for a long time anyway, but hundreds still turned up to the mass giveaway, hoping to get some of the clothes. The police had to be called to restore order.

The first offices of Apple Music Publishing were located above the Baker Street shop. The company was launched with a well-meaning ad in the *New Musical Express*, which led to The Beatles receiving thousands of demo tapes. Most of the tapes were dreadful, and no new writers were found.

Soon it became obvious that the Baker Street offices were too small, and Apple took new premises in Wigmore Street.

A Blue Plaque to John Lennon and George Harrison was unveiled at 94 Baker Street in March 2013.

Marylebone Register Office The site of three Beatles weddings. Paul married Linda Eastman on 12 March 1969; Ringo married Barbara Bach on 27 April 1981; and Paul returned to marry Nancy Shevell on 9 October 2011. Linda, Barbara and Nancy all grew up in the New York City area, and all have Jewish heritage.

NEW YORK CITY

1963

11 Nov — Brian Epstein meets Ed Sullivan at the Delmonico Hotel to arrange first appearance on his show

18 Nov — First report about The Beatles airs on *NBC News*

22 Nov — Report about The Beatles appears on morning news on CBS; bumped from evening broadcast by coverage of the Kennedy assassination

1964

9 Feb — The Beatles make their first appearance on *The Ed Sullivan Show*

12 Feb — The Beatles perform at Carnegie Hall

28 Aug — The Beatles come to the Delmonico Hotel; St Cristopher medal affair; first show at Forest Hills Stadium

29 Aug — Second show at Forest Hills

20 Sept — The Beatles perform at the New York Paramount

1965

15 Aug — First Beatles performance at Shea Stadium

1971

6 June — John and Yoko appear with Frank Zappa at Filmore East

1 Aug — George's 'Concert for Bangladesh' takes place at Madison Square Garden

10 Dec — John and Yoko perform at the Apollo Theater for an Attica fundraiser

30 Aug — John and Elephant's Memory perform 'One to One Concert' at Madison Square Garden

1974

15 Nov — John filmed in a jaunt through Central Park

28 Nov — John appears with Elton John at Madison Square Garden; his last live performance

1980

7 Aug — John and Yoko start recording *Double Fantasy* at The Hit Factory

8 Dec — John and Yoko record 'Walking on Thin Ice' at The Record Plant

John is shot and killed outside the Dakota later that night

1985

9 Oct — Strawberry Fields is dedicated in Central Park

2001

2 Oct — The 'Come Together' concert honouring John is held at Radio City Music Hall

NEW YORK CITY MAPS

1 APOLLO THEATER
2 CENTRAL PARK
3 FOREST HILLS STADIUM
4 SHEA STADIUM/CITI FIELD
5 BARCLAYS CENTER
6 JOHN F KENNEDY INTERNATIONAL AIRPORT
7 STATUE OF LIBERTY

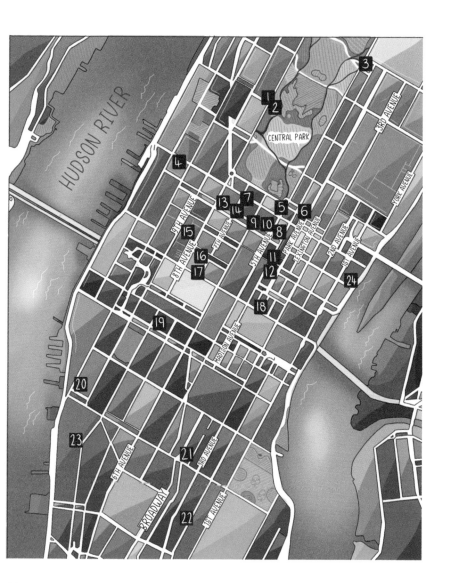

1 THE DAKOTA APARTMENTS
2 STRAWBERRY FIELDS
3 1045 FIFTH AVENUE
4 CBS BROADCAST CENTER
5 THE PLAZA HOTEL
6 HOTEL DELMONICO
7 CARNEGIE HALL
8 ST.REGIS HOTEL
9 WARWICK HOTEL
10 EASTMAN & EASTMAN/MPL OFFICE
11 RADIO CITY MUSIC HALL
12 NBC STUDIOS
13 ED SULLIVAN THEATER
14 1700 BROADWAY/ US APPLE OFFICES/OFFICE OF ALLEN KLEIN
15 THE HIT FACTORY
16 THE RECORD PLANT
17 PARAMOUNT THEATER/HARD ROCK CAFE
18 GRAND CENTRAL TERMINAL
19 MADISON SQUARE GARDEN
20 HIGHLINE BALLROOM
21 IRVING PLAZA
22 FILLMORE EAST
23 105 BANK STREET
24 434 EAST 52ND STREET

Imagine Mosaic, Strawberry Fields, Central Park, centrepiece of the 'Garden of Peace'.

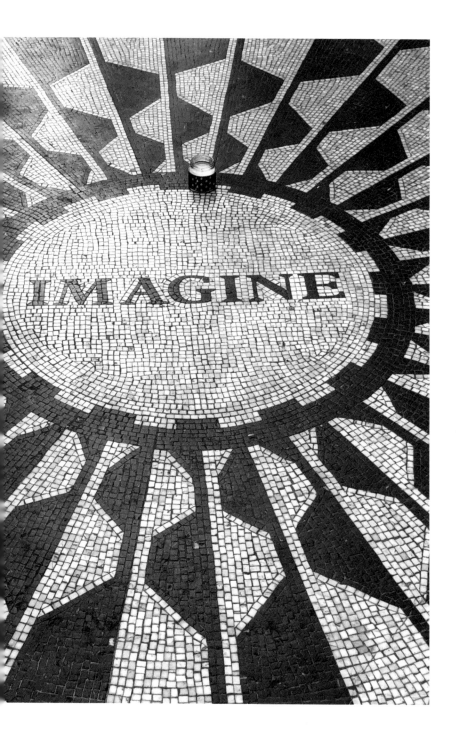

New York, like Liverpool, Hamburg and London, is a major port city. Its large natural harbour made the city the main trading centre on the East Coast, including sending cotton from the American South to Liverpool, while millions of immigrants from Europe, including the United Kingdom, would come through Ellis Island in New York harbour to start new lives here.

Because of the location and the large number of people drawn here, New York has always been the centre of the development of American music. The city's contributions to music are both audacious in giving us Broadway, Tin Pan Alley, the jazz that came out of the Harlem Renaissance, and the doo wop of the 1950s, and subtle by being the headquarters of the performing rights organizations ASCAP and BMI and host of national broadcast networks that helped to spread this music around the country.

There's an impression that before The Beatles came over, the American music scene was in need of inspiration; that having lost Elvis to the Army and MGM and Buddy Holly to a plane crash, the sleepy scene needed the jump start that the band provided. This, like a lot of legends, is not entirely accurate.

Music in the United States was actually quite vibrant prior to The Beatles. In New Orleans, Allen Toussaint was producing such hits as 'Mother-In-Law' and 'I Like It Like That' with artists on the Mint Records label, while in Detroit, Berry Gordy had just bought a third house on West Grand Boulevard for his Motown Records empire to expand into. Chicago had Chess Records, and Stax Records in Memphis were still releasing popular hits, such as Jan Bradley's 'Mama Didn't Lie' and Otis Redding's 'Pain in My Heart'. And Los Angeles was just starting to make its impact on the music scene, with The Beach Boys' *Little Deuce Coupe* from October of 1963 at the vanguard of the surf music genre.

New York itself was also busy. The famous Brill Building was a base for such prolific hit songwriters as Leiber and Stoller and Goffin and King. Acts based in the greater New York City area included Neil Sedaka, The Four Seasons, The Crystals and Lesley Gore, some of the more prominent examples of the commercial music scene. In contrast, down in Greenwich Village, Joan Baez and Bob Dylan were raising the profile of folk music, high enough that the series *Hootnanny* was broadcast on the ABC network, a counterbalance to its other musical showcase, *American Bandstand*.

Contrary to popular myth, America was not completely closed off to British acts before 1964; two years earlier, the single 'Telstar' by London's Tornados charted in the US. However, other British performers such as Cliff Richard and Helen Shapiro did not achieve any following in the

US despite appearing on *The Ed Sullivan Show* before The Beatles did. There was a perception, however erroneous, that British acts just could not make it in the United States because their music was not suited to American audiences, who were more interested in the rock 'n' roll and R&B that was simply not part of the repertoire of many of the performers from across the Atlantic.

The Beatles, however, were different. Instead of recording the kind of music that seldom, if ever, allowed British acts to take hold in the United States, their unique perspective came from the American rock and R&B records they listened to at home. They did not simply regurgitate American rock 'n' roll like many of their countrymen; on the contrary, they turned it on its ear, creating a kind of sound that no one had ever quite heard before.

There were undoubtedly other factors that contributed to The Beatles' success in America – particularly in the timing. Historians have noted that they arrived in New York only a few months after the assassination of President John F. Kennedy and a period of national mourning, during a time when baby boomers were becoming teenagers with disposable income just waiting to be spent on something exciting and different. The fact that so many American households had televisions by that time, and that watching Ed Sullivan was a Sunday night ritual in most of those homes, also helped their meteoric rise.

If The Beatles were born in Liverpool, honed their craft in Hamburg and grew up in London, they truly became an international phenomenon in New York. It was their appearance on *The Ed Sullivan Show* on 9 February 1964 that truly took the world by storm, introducing them to millions of people on a scale they could never have imagined and sparking full-blown, worldwide Beatlemania. Indeed, this historic appearance could be considered the beachhead for the 'British Invasion' that followed. This, coupled with the persistence of music promoter Sid Bernstein, who had contacted Brian Epstein as early as March 1963 to try and book The Beatles to appear at Carnegie Hall and who finally succeeded in doing so for an appearance on 12 February 1964, quite literally changed the course of music promotion in the United States forever after.

Two quotes attributed to John Lennon himself have captured what it was that drew not only him, but everyone who ever came, to New York:

"If I'd lived in Roman times, I'd have lived in Rome. Where else? Today America is the Roman Empire and New York is Rome itself."

"I regret profoundly that I was not an American and not born in Greenwich Village. It might be dying, and there might be a lot of dirt in the air you breathe, but this is where it's happening."

The Plaza Hotel, first stop for The Beatles on their inaugural NYC trip.

FAB FOUR HOMES AND HOTELS

The Plaza Hotel, 768 Fifth Avenue (at Central Park South)

The Plaza is one of the grand old hotels of New York City. It is located in Midtown Manhattan, at the corner of Central Park and Fifth Avenue on the west side of Grand Army Plaza. It was granted New York City landmark status in 1969, and became a National Historic Landmark in 1986. It was designed by Henry Janeway Hardenburgh, the same architect who had previously designed the Dakota Apartments in the 1880s, in an ornate French chateau style.

After arriving at JFK Airport and holding a press conference on 7 February 1964, The Beatles were whisked away to The Plaza, where a reservation had been made informing the hotel that they were four "British businessmen". Needless to say, the hotel and its staff did not anticipate the hysteria that would follow the group to the hotel, and at least 50 members of the NYPD were deployed around The Plaza to keep the screaming fans at bay. Much of the hysteria was documented by news cameras, and there is newsreel footage of the crowds of fans teeming outside the hotel, including some interviews.

The Beatles occupied the Presidential Suites on the 12th floor (Rooms 1209-1216). While there, they watched news reports about their arrival on television, and conducted phone interviews with local DJs, including Murray the K (Murray Kaufman) of WINS. Much of this interaction was documented by the Maysles Brothers in their film *The Beatles: The First U.S. Visit* which gives a first-hand account of what it was like to be in the eye of the storm.

Hotel Delmonico, 502 Park Avenue (at 59th Street)

The Hotel Delmonico is where The Beatles stayed when they returned to New York in the summer of 1964 on their first complete American tour. Currently, it is the Trump Park Avenue and is no longer a hotel, but is a building owned by Donald Trump containing 120 condominium apartments and 8 luxury penthouses.

In the early '60s, the Delmonico was also the residence of Ed Sullivan, host of the most popular variety program on American television. It was here in November 1963 that Brian Epstein met with Sullivan to hammer out the details of bringing The Beatles to America to appear on Sullivan's program in February 1964.

The Beatles arrived in New York to a screaming crowd of 3,000 fans at 2.55am on the day of their concert at Forest Hills Stadium, and were whisked away to the Delmonico, where even more hysterical fans awaited them. In the frenzy as they entered the hotel, Ringo's shirt was torn, and a St Christopher medallion that he was wearing was ripped from his neck. During a live broadcast with Cousin Brucie of WABC, Ringo pleaded for its return, and whoever returned it would get to meet The Beatles. A girl named Angie McGowan came forward and said that she had the medallion. She later told reporters, "I grabbed him around the neck to kiss him, but I was shoved back in the crowd. Then I looked at my hand. I thought I had a button, but discovered it was a medal."

A press conference was also held at the Delmonico, during which the band praised all things American. It was also while staying here that Bob Dylan met The Beatles and introduced them to marijuana, although some sources erroneously report that this happened at The Warwick Hotel.

The Warwick Hotel, 65 West 54th Street (at Sixth Avenue)

In 1965, The Beatles stayed at The Warwick Hotel when they came to play at Shea Stadium. After the screaming hordes of fans during their first visit to New York, The Plaza did not allow them to return, and so they had to find a new place to stay. They stayed at The Warwick again when they returned to New York in the summer of 1966, and it

The main entrance to The Warwick Hotel, host to The Beatles on two occasions.

was here that they gave two press conferences, one for the regular mainstream media, followed by a 'junior' press conference for 150 young fans who were chosen at random through postcard entries received by radio station WMCA and the US Beatles Fan Club. This junior press conference was The Beatles' own idea in the hopes that it would change the format a bit and allow for different kinds of questions. Each attendee was given a Beatles gift pack when they arrived, consisting of signed photographs of the band. It was also during this press conference that John Lennon was given a guitar from the Guild Guitar Company of Hoboken, New Jersey – a custom Guild Starfire XII electric 12-string guitar that was presented to him by Mark Dronge, the son of the company's founder, Alfred Dronge. The guitar later came into the possession of Yoko Ono's former husband, Tony Cox, who sold it to the Hard Rock Cafe. As far as anyone knows, it was never used by Lennon on any Beatles recording.

St. Regis Hotel, 2 East 55th Street (at Fifth Avenue)

John Lennon and Yoko Ono lived at the St. Regis Hotel when they first came to New York City in 1971. The hotel has always had many famous residents, including Salvador Dalí, Marlene Dietrich and Nikola Tesla. It was here at the St. Regis that Lennon conceived and recorded an acoustic demo of his song 'Happy Xmas (War Is Over)', which was later refined during Lennon and Ono's time living at 105 Bank Street in Greenwich Village.

105 Bank Street (at Greenwich Street)

John and Yoko lived in this unassuming row house in Greenwich Village after leaving the St. Regis Hotel. In October 1971, they rented a two-bedroom apartment from Joe Butler, drummer for The Lovin' Spoonful, and remained in Bank Street until 1973. The neighborhood then was not the thriving West Village of today, but was barely gentrified. It was here at Bank Street that they began hanging out with musicians and social activists who came to visit them in the back bedroom, which boasted a large skylight and spiral staircase. Jerry Rubin, Allen Ginsberg, actor Peter Boyle and Black Panther Bobby Seale all came through the doors at one point or another. Lennon befriended musician David Peel,

whose band was playing in nearby Washington Square Park, and later produced Peel's album *The Pope Smokes Dope*. Peel appeared with Lennon at the One to One Concert at Madison Square Garden.

Living at Bank Street afforded Lennon the relative anonymity he craved in New York City. After high visibility at the St. Regis Hotel, it allowed him and Ono to live quietly and enjoy the city and all it had to offer. It was not all perfect, however – it was also while they were living on Bank Street that the FBI stepped up their surveillance under the auspices of Director J. Edgar Hoover, who ordered the agency to locate Lennon so that the Immigration and Naturalization Service could deport him. After the apartment was robbed in 1972, the couple looked for a more secure location, finally settling on the Dakota Apartments at 72nd Street and Central Park West.

The Dakota Apartments, One West 72nd Street (at Central Park West)

The Dakota Apartments building was home to John and Yoko from 1973 until Lennon's death in 1980. Yoko still lives there – she has never moved and still resides in Apartment 72, the same one she shared with John. It was here in December 1980 that Lennon was shot and killed.

The building was constructed between 1880 and 1884, though the figurehead date plaque at the top of the main gable says 1881. The building was designated a New York City Landmark in 1969, and a National Historic Landmark in 1976.

There are two stories about why the building was called the Dakota – one that is an urban legend and one that is likely the true reason. The former states that the name stems from the fact that when the building was constructed, it was so far away from everything else in the city that people said it might as well have been in the Dakota Territory (this story first appeared around 1933). The more likely reason, however, stems from Clark and Hardenburgh's fascination with native peoples and the names of the new western states and territories. Additionally, the figurehead at the top of the façade is of a Dakota Indian, lending credence to that story as the real reason for the name.

John and Yoko enjoyed something like a 'normal life' during their time in Greenwich Village. Photograph by Brian Hamill.

In 1973 John and Yoko moved uptown, to The Dakota Apartments on the edge of Central Park.

When Lennon and Ono first expressed a desire to live at the Dakota, a cooperative building that requires approval from a Board of Directors for admittance, they met considerable resistance from the board and some residents. There was a fear that they might bring an unwanted element into the building, in particular because John was fighting to stay in the country; the authorities were using drug-related charges from his days in England to deny him residency in the US. Some residents were also concerned that John and Yoko would bring wild rock 'n' roll parties to the building, with loud music. However, once they were admitted, the couple proved to be model neighbours, mostly keeping to themselves.

The Dakota switchboard had to field numerous phone calls from fans asking to be put through to Lennon's apartment, and fans frequently congregated outside the entry gates trying to catch a glimpse of the couple. Occasionally, their vigil was rewarded with a sighting, or even a short interaction – including the fateful encounter on 8 December

1980, when Lennon actually autographed a copy of *Double Fantasy* for the man who would return later that day to shoot him dead.

It was also during the couple's residency in the Dakota that Lennon famously became a 'house husband', devoting his time to raising his son Sean, baking bread, and retreating from the world. However, contrary to popular belief, he was not completely removed from music during those five years from 1975 to 1980. Instead, he produced demos and recordings that were later included on *Double Fantasy* and *Milk and Honey*, as well as demos for the songs 'Free as a Bird' and 'Real Love', which were later used to create Beatles 'reunion' singles for *The Beatles Anthology* project in 1995.

The Dakota has had many other famous residents over the years. Judy Garland, Leonard Bernstein, Rosemary Clooney and Lauren Bacall and Rex Reed have all called the building home. It also featured prominently in the film *Rosemary's Baby*, where it served as the home of the main characters.

434 East 52nd Street (between First Avenue and Sutton Place)

John Lennon and May Pang, with whom Lennon had an 18-month relationship, rented a penthouse apartment in this building overlooking the East River and Queens. It was while living here in August 1974 that they claimed to have seen a UFO from the terrace, and also where Bob Gruen took his famous photographs of Lennon wearing his New York City t-shirt on the rooftop balcony.

1045 Fifth Avenue (between East 85th and East 86th Streets)

It was here in 2015 that Paul McCartney and his wife, Nancy Shevell, purchased a ten-room penthouse, originally constructed in 1967 for the building's developer, Manny Duell. McCartney paid the full asking price of $15,500,000 for the duplex, which has beautiful views of Central Park from the windows on both floors. Unlike most co-ops on the Upper East Side, this building allows residents to live there part-time, so McCartney and Shevell can use it as a pied-à-terre rather than a primary home in New York.

RECORDING STUDIOS

The Hit Factory, 353 West 48th Street (between Eighth and Ninth Avenues)

The Hit Factory was a recording studio with multiple locations in Manhattan. In August 1980, after five years out of the public eye, John Lennon and Yoko Ono began working at the studio with producer Jack Douglas on what would become the album *Double Fantasy*. After a sailing trip from Rhode Island to Bermuda earlier in the year, during which Lennon was forced to take the wheel of the yacht during severe storms, he emerged reinvigorated and began writing new songs and reworking existing demos. Ono also wrote some new songs – after hearing the B-52s 'Rock Lobster', Lennon encouraged her by saying that the time had come when the world would be ready for her music.

The recording sessions were top secret when they began, as Lennon and Ono were not signed to a record label and had not yet announced that they were returning to public life. They produced dozens of songs, enough for this album and a second one that later became the posthumous release *Milk and Honey*. Once they were satisfied that the sessions were going well and the music was strong, their publicist was allowed to announce that they were back in the studio, and almost immediately they were inundated with offers from record labels, eventually signing with the brand-new Geffen Records, chosen because David Geffen spoke with Ono first and regarded her songs as equal to Lennon's. The album was released on 17 November 1980.

There are contradictory reports about where Lennon and Ono were working on the day of Lennon's death, 8 December 1980. Most sources state The Record Plant as the location, including producer Jack Douglas, though one secondary source, Beatles biographer Keith Badman, says it was The Hit Factory.

The Hit Factory, where John and Yoko recorded *Double Fantasy*.

The former location of The Record Plant is now an apartment building.

The Record Plant, 321 West 44th Street (between Eighth and Ninth Avenues)

The Record Plant was a recording studio on the west side of Manhattan. It opened in 1968, and in 1970 was the first studio designed for recording quadrophonic sound. In 1971 The Record Plant made its first remote recordings at George Harrison's Concert for Bangladesh at Madison Square Garden, and the live album was mixed and produced there.

On the last day of his life, John Lennon is thought to have been working at The Record Plant on the recording of Yoko Ono's song 'Walking on Thin Ice', which was later released as a single. In fact, when Lennon was shot, he was carrying tapes of the song in his hands.

Numerous other Lennon albums were worked on or recorded at The Record Plant, including *Imagine*, *Mind Games*, *Rock 'N' Roll* and *Walls and Bridges*. The studio was sold to Sir George Martin in 1987 and closed soon afterwards. However, the building lives on as "The Plant," containing the offices of *The New York Observer* newspaper. In 2012, Jared Kushner (yes, *that* Jared Kushner) sold the building to two development firms for $95 million in an off-market deal. The tenth floor studio is still there, active as a mastering studio owned by Sony Music Entertainment, known as Battery Studios, and there is also a roof deck that can be rented for parties and corporate functions.

IMPORTANT NEW YORK CITY CONCERTS

Carnegie Hall, 881 Seventh Avenue at West 57th Street, New York City

12 February 1964

Carnegie Hall is known as the most prestigious concert hall in the world. Built in 1891 and designed by William Burnet Tuthill for Andrew Carnegie, the philanthropist who accrued his fortune through railroads and steel, it has 3,671 seats divided among three concert halls.

The Beatles played at Carnegie Hall on 12 February 1964, as part of their initial visit to the United States. Although they were not the first rock act to play the Hall (that honour goes to Bill Haley and the Comets in 1955), this show introduced more regular booking of rock and pop acts at the venue.

After performing on *The Ed Sullivan Show* on 9 February, The Beatles took the train to Washington, D.C. to do their first concert in the US, at the Washington Coliseum. They returned to New York on 12 February to a crowd of 10,000 fans waiting for them at Penn Station due to the Lincoln's Birthday holiday. After a quick trip back to The Plaza Hotel to change clothes, they were smuggled out through the kitchens to Carnegie Hall, where they were scheduled to do two shows, at 7:45pm and 11:15pm, each 35 minutes long. The concerts were organised by promoter Sid Bernstein, who would later bring the band to play at Shea Stadium. Tickets had gone on sale on 27 January, completely selling out by the next day.

When the band arrived, they were greeted backstage by various guests and by representatives from Swan Records, who presented them with a gold record for 'She Loves You'.

At the time, there was a practice of setting up seats on the stage during select chamber music concerts, and this practice was in play during The Beatles' shows. Archival photos from Carnegie Hall show fans sitting on seats behind the band, including one woman holding a movie camera. Although over the years people have asked about this woman and her footage, no one has been able to locate her or the film. Beatles producer George Martin wanted to record the concerts, but although Capitol Records agreed to the plan, permission was denied by the American Federation of Musicians.

Carnegie Hall again played host to one of The Beatles when Paul McCartney's three classical works, *The Liverpool Oratorio*, *Standing Stone* and *Ecce Cor Meum*, all had their US premieres at Carnegie Hall in 1991, 1997 and 2006 respectively. Although Paul himself did not perform at any of these shows (the pieces are orchestral and choral in nature, not rock or pop), he was in attendance and did emerge from his box at the end of each show to take a bow and well-deserved credit.

On his first visit to Liverpool in 1902, Andrew Carnegie, for whom the New York hall was built, attended the opening ceremony of Toxteth Library on Windsor Street, opposite the house where John's Aunt Mimi was born. He gave grants to construct six branch libraries in Liverpool.

Sid Bernstein telephoned Brian Epstein in Liverpool to set up the 1964 Carnegie Hall concert after reading about The Beatles in a British newspaper.

The Beatles played at Forest Hills Stadium on their second visit to New York.

Forest Hills Stadium,
One Tennis Place,
Forest Hills, Queens

28/29 August 1964

Forest Hills Stadium is a 14,000-seat venue that is part of the West Side Tennis Club in Queens, New York. The Beatles played here on their 1964 tour of the US as part of the fifth Forest Hills Music Festival, on 28 and 29 August. This was a very busy time in Queens because the 1964 World's Fair was also happening in nearby Flushing Meadows-Corona Park.

Fans lined up in early May that year to buy Beatles tickets costing between $2.95 and $6.50 from the Festival ticket office on Queens Boulevard. Additionally, numerous contests were held for supporters to win free tickets, including one in which entrants had to sum up why they wanted to see The Beatles in 25 words or less.

After The Beatles arrived in New York and went to the Delmonico Hotel to change, they were taken by limousine to a heliport in lower Manhattan, and were flown to Forest Hills. Five hundred police officers, private detectives, ambulances and fire hoses were deployed to quell the hysteria of over 16,000 fans as the helicopter landed on one of the grass tennis courts. The emcees on the first night were the disc jockeys known as the WMCA Good Guys, and on the second night, Murray the K.

**Shea Stadium/
Citi Field, 123-01
Roosevelt Avenue/41
Seaver Way,
Flushing, Queens**

15 August 1965
23 August 1966

Shea Stadium was a multi-purpose venue in Flushing, Queens. It opened in 1964, and was the home to the New York Mets baseball team from 1964-2009 and the New York Jets football team from 1964-1983. It was named after William A. Shea, the man who was responsible for bringing National League baseball back to New York after the Giants and Dodgers left in 1957. In 2009, it was demolished to create the parking lot for the new home of the Mets, Citi Field. Shea opened five days before the 1964-65 World's Fair, held across Roosevelt Avenue in Flushing Meadows-Corona Park, and although it was not officially a part of the fair, it was decorated with blue and orange steel panels, the colours of both the fair and the Mets.

On 15 August 1965, The Beatles played at Shea Stadium to a record crowd of 55,600. It was the first concert held at a major stadium, and paved the way for arena rock as we know it today. It set records for attendance and revenue and proved that large-scale outdoor concerts could be lucrative. The show was held at the height of Beatlemania, and film footage from the concert shows screaming, fainting fans and policemen holding their hands over their ears to mute the deafening sound. Because they did not have any monitor speakers, The Beatles themselves could not hear the music over the sound of the audience. This concert was filmed for a 50-minute documentary entitled *The Beatles at Shea Stadium*, which was directed and produced by Bob Precht of Sullivan Productions, NEMS Enterprises (which holds the 1965 copyright) and The Beatles' company Subafilms. The success of the 1965 concert was such that The Beatles returned to Shea again on 23 August 1966.

The last concerts at Shea were by Billy Joel on 16 and 18 July 2008, and are immortalised in the film *Last Play at Shea*. On the final night of Joel's stand, Paul McCartney joined him onstage to close the show and sang 'Let It Be', thus bookending Shea's history as a concert venue.

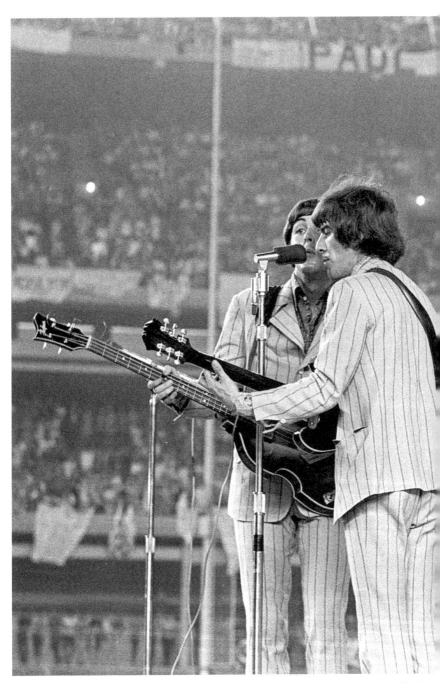

Live in concert at Shea Stadium, 23 August 1966. Photograph by Bob J. Collister, provided courtesy of The Beatles PHOTO NEGATIVE COLLECTION, Robert Kern, Austria.

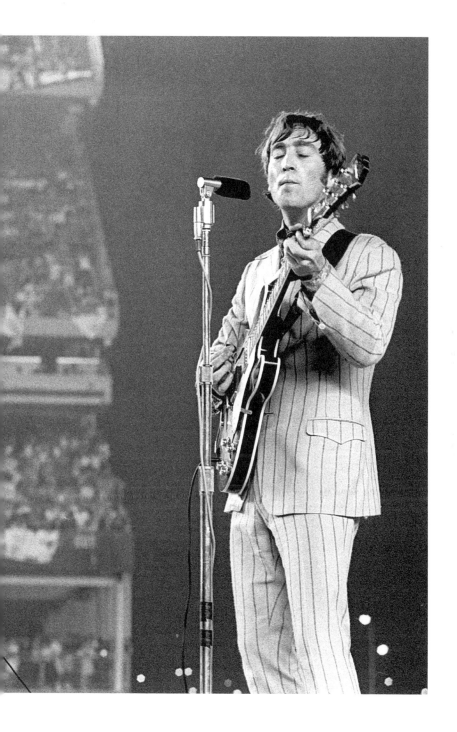

Citi Field was constructed as a replacement for Shea Stadium and was built in the parking lot before Shea was then demolished. There are markers in the car park indicating the spots where the home plate and the pitcher's mound were originally located.

**Madison Square Garden,
4 Pennsylvania Plaza
(at Seventh Avenue
and West 33rd Street)**

1 August 1971
– Concert for
Bangladesh
30 August 1972 – One
to One Concert
28 November 1974 –
John with Elton John
20 October 2001 –
The Concert for New
York City

Madison Square Garden, or 'The World's Most Famous Arena', known otherwise as 'The Garden' or 'MSG', is the fourth arena to bear this name. The current Garden opened in 1968, and is the oldest major sporting arena remaining in the New York City area. It is home to New York Rangers hockey and New York Knicks basketball.

The Beatles never played Madison Square Garden as a group – in 1964, after their last show at Carnegie Hall, promoter Sid Bernstein approached Brian Epstein with an offer of $25,000 plus $5,000 to the British Cancer Fund for a concert the following week at the old 8th Avenue Garden, but Epstein brushed off the suggestion and a concert never materialised.

On 1 August 1971, George Harrison and Ravi Shankar organised the Concert for Bangladesh at the current location of MSG. Two benefit concerts were held, at 2:30pm and 8:00pm, to raise funds for the relief of refugees from East Pakistan. By 1985, an estimated $12 million had been raised for this cause. Sales of the attendant album and film still benefit The George Harrison Fund for UNICEF, and the concert is recognised as the first successful event of its kind, serving as inspiration for future benefit concerts such as Live Aid.

One year later, in August 1972, John Lennon and the members of the band Elephant's Memory appeared at two concerts (one in the afternoon and one in the evening) to benefit the Willowbrook State School at the request of journalist Geraldo Rivera, who had broken the story of mistreatment of the intellectually disabled residents of the institution located in Staten Island. Known colloquially as the 'One to One Concert', the shows were recorded and featured

Madison Square Garden, "The World's Most Famous Arena".

other performers such as Stevie Wonder, Roberta Flack and Sha Na Na. An album of Lennon at the show, entitled *Live in New York City*, was released in 1986, but does not include the performances by the other acts. The album is a snapshot of Lennon's last full-length live concert, and in addition to his most recent material at the time, includes performances of 'Come Together' and Elvis Presley's 'Hound Dog', as well as an extended version of 'Give Peace a Chance' that is an audience singalong.

In November 1974, John Lennon once again appeared at The Garden, this time with Elton John. The appearance that would be Lennon's final one before a live audience began with a wager. Elton played piano on Lennon's 1974 album *Walls and Bridges*, specifically on the song 'Whatever Gets You Through the Night', so he bet Lennon that the song would reach No. 1 – something Lennon was very sceptical about, since he was the only Beatle yet to top the charts in his solo career. He accepted Elton's bet, never expecting that the song would reach No. 1 – and when it did, he made good on the bet and appeared at Madison Square

Garden on Thanksgiving night, 28 November, performing three songs: 'Whatever Gets You Through the Night', 'Lucy in the Sky With Diamonds' and 'I Saw Her Standing There', the live version of which became the B-side of Elton's single 'Philadelphia Freedom' in 1975.

In 1976, Paul McCartney and Wings played at MSG as part of their Wings Over the World tour.

On 20 October 2001, a little over a month after the September 11 attacks, The Concert for New York City was held at MSG, organised by Paul McCartney and featuring legendary acts such as The Who, David Bowie, Elton John, Eric Clapton, Bon Jovi, Jay-Z, Destiny's Child, Backstreet Boys, Billy Joel and James Taylor. The concert was conceived as a benefit in response to the attacks, and also honoured the first responders from the NYPD and FDNY, including those lost in the attacks and those who were still working at Ground Zero. The concert raised over $35 million, with an additional $275,000 raised through a concurrent auction of signed memorabilia for the Robin Hood Foundation.

Radio City Music Hall, 1260 Sixth Avenue at West 50th Street, New York City

Various dates post-Beatles

Radio City Music Hall is the largest and best-preserved Art Deco-style theatre in the United States. It is part of the Rockefeller Center complex, and is home to the *Radio City Christmas Spectacular*, featuring the Rockettes, the world-famous chorus line. In October 2001, a concert called Come Together: A Night for John Lennon's

One of Liverpool's first No. 1 artists was Michael Holliday, born Norman Milne, who, as a 'Cunard Yank', brought Jazz records into Liverpool. While working as a travelling seaman, he won a talent contest at Radio City Music Hall in New York, which led to him turning professional.

Radio City Music Hall, opened in 1932.

Words and Music was held at Radio City. Originally planned to celebrate Lennon's life and accomplishments, it was delayed following the terrorist attacks of 11 September and then turned into a benefit for "New York City and its people", raising money for the Robin Hood Foundation to aid first responders and other New Yorkers affected by the attacks. Participants included Yoko Ono, Sean Lennon, Cyndi Lauper, Alanis Morrissette, Billy Preston and Lou Reed. The show was hosted by Kevin Spacey, who also exhibited his singing prowess by performing a rendition of Lennon's 'Mind Games' at the close of the show, and was broadcast on television, on the WB and TNT networks.

In April 2009, Paul McCartney and Ringo Starr reunited on the Radio City stage during a benefit for the David Lynch Foundation called Change Begins Within, with proceeds going towards teaching at-risk children to meditate. Donovan (who was with The Beatles when they studied meditation in India with the Maharishi Mahesh Yogi), Sheryl Crow and Eddie Vedder, among others, were also part of the show.

Ringo Starr has played at Radio City with nearly every iteration of the All-Starr Band since 1989. The most notable concert occurred on Ringo's 70th birthday in 2010, when Paul McCartney made a surprise appearance to sing 'Birthday' to his old bandmate. The crowd went wild as McCartney came onstage after Yoko Ono, Joe Walsh, Steven Van Zandt and Angus Young joined Starr for the supposed finale, a rendition of 'With A Little Help From My Friends', the usual ending for All-Starr Band shows.

Paramount Theater/ Hard Rock Cafe, 1501 Broadway (at West 43rd Street)

20 September 1964

The Paramount Theater was originally a movie palace in Times Square. The building in which it was located (The Paramount Building) was also the headquarters of Paramount Pictures. Disc jockey and promoter Alan Freed presented his rock and roll shows there (and also at its sister theatre, the Brooklyn Paramount), and it was the site of the premiere of Elvis Presley's first film, *Love Me Tender*, as well as a performance by Buddy Holly and the Crickets,

who performed 'Peggy Sue' there after it hit the charts. The theatre closed in 1964, the marquee and grand arch were demolished, and it was gutted and turned into shops and office space for *The New York Times*. In the early 2000s, a section of the building was leased to the World Wrestling Federation for their new restaurant, and the arch and marquee were restored. The restaurant closed in 2003 and was taken over by the Hard Rock Café, which relocated here from its original New York location on 57th Street.

The Beatles played at the New York Paramount on the last day of their first full US tour, 20 September 1964, as part of a charity concert to benefit United Cerebral Palsy. The group took no fee for this performance, though ticket prices ranged from $5 to $100 each. The lower-priced tickets were mostly sold to teenage fans; the more expensive tickets went to members of New York's wealthy elite. Altogether, 3,682 people saw the show, but 240 members of the NYPD were deployed in the area to keep thousands of other fans at bay as they jammed traffic in the Times Square area. The show started at 8:30pm, though The Beatles did not hit the stage until nearly 10:45pm, when they performed a set of ten songs, all the while drowned out by the screaming fans in the audience, who danced in the aisles and pelted the band with jelly beans.

Following their performance, the group was presented with a scroll by the chairman of UCP, Leonard Goldenson, that read: "To Jack Lennon [sic], George Harrison, Paul McCartney, Ringo Starr who, as The Beatles, have brought an excitement to the entertainment capitals of the world and who, as individuals, have given of their time and talent to bring help and hope to the handicapped children of America."

Fillmore East, 105 Second Avenue at East Fifth Street, New York City

6 June 1971 – John, Yoko and Frank Zappa

The Fillmore East was a rock venue on the Lower East Side of Manhattan run by promoter Bill Graham. It was the east coast companion theatre to Graham's Fillmore West, located in San Francisco.

On 6 June 1971, John Lennon and Yoko Ono joined Frank Zappa and the Mothers of Invention onstage at the Fillmore during their encore, playing a 30-minute set. Zappa was already recording the show, which was later released as a live album entitled *Fillmore East – June 1971*. The portion of the show during which Lennon and Ono appeared was released as a bonus disc included in their album *Some Time in New York City*, under the title 'Live Jam'.

The Fillmore East closed 19 days after this show, though it did have further life as a music venue under other names until 1988. Today, it is a bank.

Apollo Theater, 253 West 125th Street, New York City)

17 December 1971

The Apollo Theater is a famous venue located in Harlem, New York City. Long a showcase for African-American talent, it is the home of *Showtime at the Apollo* and the legendary *Amateur Night*, showcasing new and untapped performers. In 1971, John Lennon and Yoko Ono appeared at the Apollo as part of a concert to raise money for the families of the victims of the recent Attica State prison riot. It was Lennon's second live solo performance in the United States and was virtually ignored by the media – the only account of the show appeared in the local Harlem paper *The Amsterdam News*. Ono sang 'Sisters O Sisters' and Lennon closed the set with a solo acoustic rendition of 'Imagine'.

Highline Ballroom, 431 West 16th Street

13 June 2007

The Highline Ballroom was a 700-seat venue located in West Chelsea, Manhattan. It presented all genres of music, and closed in February 2019 with a show by The Roots. On 13 June 2007, Paul McCartney played a secret gig at the Highline to promote his new album, *Memory Almost Full*. The show was a follow up to a similar show staged in London the week before, and was announced only a couple of days previously.

Irving Plaza,
17 Irving Place

14 February 2015

Irving Plaza, which has also operated as a music venue under the names The Ritz and The Fillmore New York at Irving Plaza, is a ballroom in the Union Square area of Manhattan. It is a very small theater, seating only approximately 1000 people. On 14 February 2015, Paul McCartney played a surprise show at Irving Plaza, with tickets going on sale immediately after an announcement on Twitter. He was already in New York that weekend to appear the following day on *Saturday Night Live's* 40th Anniversary prime-time TV special when he decided to do this show, and dedicated his song 'My Valentine' to his wife, Nancy Shevell. The show lasted approximately 100 minutes, and McCartney played a shortened version of the show he usually did at large arenas, also inserting some of his favourite 1950s tunes into the mix.

Grand Central
Terminal,
89 East 42nd Street
(at Park Avenue)

7 September 2018

Grand Central Terminal is a commuter railroad station located in Midtown Manhattan that serves as the terminus for the Metro-North Railroad, a commuter train line serving the northern suburbs of New York City. On 7 September 2018, Paul McCartney played a surprise show in Vanderbilt Hall to promote his new album, *Egypt Station*, serenading 300 sweepstakes winners and invited guests with songs from the album as well as Beatles and Wings classics, and his collaboration with Kanye West and Rihanna, 'Four Five Seconds'. In addition to the show, special limited-edition promotional *Egypt Station* MetroCards were sold to commuters.

OTHER BEATLES SITES IN NEW YORK CITY

CBS Broadcast Center, 524 West 57th Street (between Tenth and Eleventh Avenues)

The CBS Broadcast Center is a television and radio facility located in the Hell's Kitchen section of Manhattan. It was here that CBS broadcast The Beatles when they were gaining notoriety in the early '60s. A report on the *CBS Morning News* with Mike Wallace was shown on 22 November 1963, during which The Beatles were asked about their popularity and how long they thought it would last. The segment was supposed to be broadcast again that evening on the *CBS Evening News* with Walter Cronkite, but during the intervening hours the assassination of President John F. Kennedy in Dallas wiped everything else off the news slate. The segment was eventually broadcast again on 10 December.

In 2005, Ringo Starr appeared on the *CBS News Early Show* as part of their Summer Concert Series to promote his new song 'Choose Love', performing a set of songs with a band featuring his then-producer Mark Hudson and Gary Burr, among others.

Central Park, 59th Street to 110th Street, Fifth Avenue to Central Park West

Central Park, opened in 1858, covers 843 acres, between 59th Street and 110th Street (North and South) and Fifth Avenue and Eighth Avenue (East and West). For Beatles fans, Strawberry Fields, the park's living memorial to John Lennon, is the first place to start.

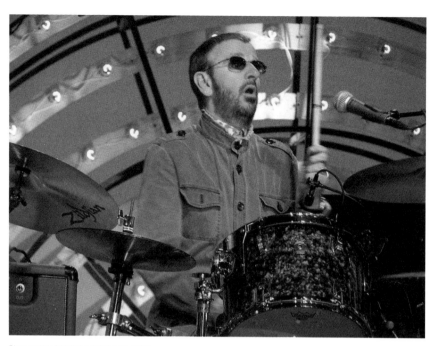

Ringo on the *CBS News Early Show*, 2005.

Strawberry Fields. West 72nd Street and Central Park West (inside Central Park). Directly across the street from the Dakota Apartments lies Strawberry Fields, a living memorial to John Lennon that was dedicated to him by Mayor Ed Koch and Parks Commissioner Henry Stern on what would have been his 45th birthday, 9 October 1985. Fans had gathered here after the news of Lennon's death began to spread in 1980, and when the time came to create an official site in memory of Lennon, this was the logical place to locate it. When given the choice between a statue and a memorial, Yoko Ono chose a living memorial, stating that "Central Park has enough statues".

Strawberry Fields occupies a 2.5-acre section of the park and was designed by landscape architect Bruce Kelly, who was able to oversee renovations to the area thanks to a $1 million donation to the Central Park Conservancy by Ono. At her request, Kelly refashioned Strawberry Fields as a 'Garden of Peace', featuring plants and flowers and other materials donated by 121 nations of the world whose names are recorded on a bronze dedication

Dedication plaque, Strawberry Fields, listing the countries that endorsed the 'Garden of Peace'.

The Naumburg Bandshell, Central Park, as seen in the video for John's 'Mind Games'. Photo: Ajay Suresh/creativecommons.org.

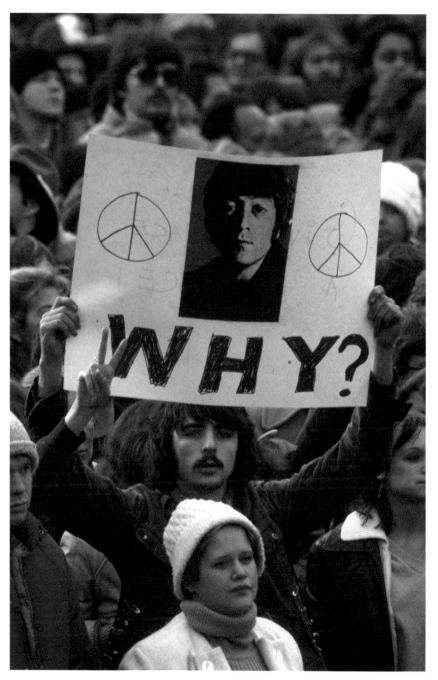

A vigil for John Lennon was held in Central Park on 14 December 1980, six days after his death. Photo by Hulton Archive/ Getty Images.

Strawberry Fields in New York is named after Strawberry Field (no 's') in Liverpool, the Salvation Army orphanage where Lennon used to go to play with the residents as a child, and the inspiration for the Beatles song 'Strawberry Fields Forever'.

plaque. The centrepiece of the garden is a black and white marble mosaic featuring the word 'Imagine'. It was designed and installed by Italian craftsmen based on a Greco-Roman design from Pompeii, and was a gift to Central Park from the city of Naples.

Strawberry Fields is a designated Quiet Zone inside the park (though visitors will often find musicians playing Beatles and Lennon songs there) and is shaded by American Elms and lined with benches, some of which bear dedication plaques. Three of the benches have Beatles-related dedications – one was dedicated by Yoko Ono in memory of an artist friend named Gianfranco Mantegna and features the title of one of her songs, 'Have You Seen a Horizon Lately?'. Another was dedicated by the people of Liverpool in memory of those who lost their lives in New York on 11 September 2001. The third was dedicated in memory of Ray Coleman, Lennon's biographer, by his family after his death.

Strawberry Fields still attracts many fans on a daily basis year-round, and is a favourite spot for city residents to find peace and solace. Of course, it is also where fans gather on Lennon's birthday and on the anniversary of his death, when people sing and celebrate his life until the wee small hours of the morning. Beatles fans also gathered here after news broke of George Harrison's death in November 2001.

Aside from Strawberry Fields, the following places in Central Park also have Beatles connections:

The Jacqueline Kennedy Onassis Reservoir. It was here that The Beatles did a photo shoot with photographer Harry Benson on Saturday, 8 February 1964. Actually, only Lennon, McCartney and Starr took part

in the photo session; George Harrison was back at The Plaza Hotel suffering from strep throat. They posed in several locations, including by the reservoir, where the Dakota can be seen in the background.

Naumburg Bandshell/Central Park Zoo/Park Benches. In October of 1974, John Lennon was followed through Central Park by a film crew, who captured him on camera wandering through the park, signing autographs, dancing on the stage and benches at the Naumberg Bandshell, going to the zoo and taking over a food cart. This footage was later used in the video for the song 'Mind Games' that was released on the *John Lennon Video Collection* in 1992 and on *Lennon Legend* in 2003.

The inspiration for Central Park was Birkenhead Park, on the opposite bank of the River Mersey to Liverpool. Designed by Joseph Paxton in 1847, Birkenhead Park was the first publicly funded civic park in the world.

Tavern on the Green. This restaurant, located at 66th Street and Central Park West, was one of the closest to the Dakota. John and his son Sean celebrated their mutual birthdays there in 1978 and 1979. In 1980, Yoko Ono hired a skywriter to write "Happy Birthday John and Sean" in the sky over the park as a special message.

Eastman & Eastman/ MPL Office, 39-41 West 54th Street (between Fifth and Sixth Avenues)

The first of these unassuming townhouses in Midtown Manhattan is home to the law offices of Eastman and Eastman, the firm founded by Lee Eastman (born Leopold Vail Epstein), father of Linda McCartney. Lee Eastman became Paul McCartney's business manager shortly before the breakup of The Beatles, and John Eastman represented him in 1970 during his lawsuit to legally dissolve The Beatles. The two Eastmans managed McCartney's solo career so successfully that he is the wealthiest of the former Beatles; they were the ones who advised him to branch out into investing in music publishing.

Next door is the New York office of MPL Communications, Ltd., Paul McCartney's company (see page 133).

Ed Sullivan Theater, 1697 Broadway (at West 53rd Street)

The Ed Sullivan Theater has been used for live and taped broadcasts on the CBS Network since 1936, and is currently home to *The Late Show* with Stephen Colbert. The theatre was known as CBS Studio 50 until it was renamed after Ed Sullivan in 1967.

Ed Sullivan was a newspaper columnist who hosted the most popular variety show in the United States. Initially called *Toast of the Town,* the show later became *The Ed Sullivan Show* and aired from 1948 to 1971; the longest-running variety program in television history. By the time The Beatles appeared on the show for the first time on 9 February 1964, Sullivan already had a reputation for presenting new and diverse acts to American audiences, such as Elvis Presley in 1956.

Approximately 73 million people watched The Beatles on *The Ed Sullivan Show*, a record number of viewers. It is said that during the one-hour program, so many people were busy watching The Beatles that there was literally no crime in America! Whether or not that is true, the fans who watched do say that the appearance made an indelible impression on them and ushered in Beatlemania in America. A variety of other British performers were also featured on the same night as The Beatles, including the cast of the musical *Oliver!,* which was on Broadway at the time. Among the cast was a young man named Davy Jones who was playing the role of the Artful Dodger – the same Davy Jones who became one of The Monkees.

The Beatles appeared on *The Ed Sullivan Show* one more time on videotape, on 12 September 1965, with a performance that was recorded one day before they kicked off their 1965 American tour with their historic show at Shea Stadium (see page 165). The show was filmed in black and white, just like those from 1964, and at

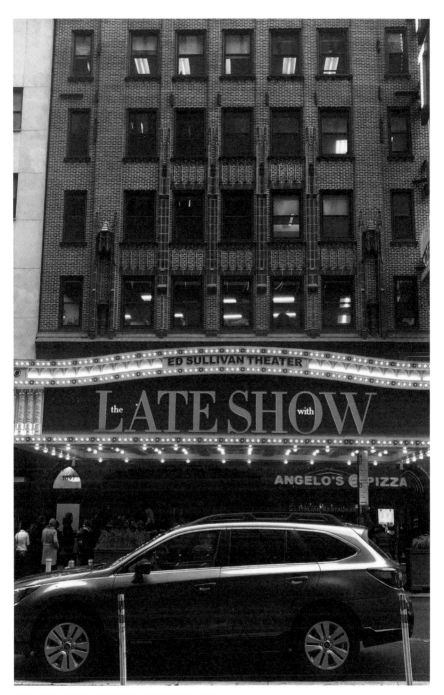

The theatre where The Beatles appeared on 9 February 1964.

the end of the evening, Sullivan announced that starting the next week, the show would be broadcast in colour; The Beatles missed having their performances preserved in colour by just one week.

In late 1963, Sullivan and his wife were at London's Heathrow airport when The Beatles were returning to England from Stockholm, and he was intrigued by the large crowd of hysterical fans that turned up to meet them. He contacted Brian Epstein and offered him a large sum for a one-off appearance. However, in order to gain more exposure for the band, Epstein negotiated with Sullivan that they would appear for a minimal fee, as long as they could be on the show three times, were promised top billing and also the opening and closing numbers on each show. The Beatles duly appeared over three consecutive weeks – the first live from Studio 50 on 9 February, then live from the Deauville Hotel in Miami Beach on 16 February and on tape on 23 February, performing three songs that had been recorded before their initial performance. During their first appearance, The Beatles looked so alike to most people that they had to be identified on screen – and when the camera panned to John, the words 'sorry girls, he's married' were added.

The first British performer on *The Ed Sullivan Show* had been the Chas McDevitt Skiffle Group, featuring Nancy Whiskey on lead vocals. Chas and Nancy performed 'Freight Train' on 30 June 1957.

NBC Studios, 30 Rockefeller Plaza

The Beatles, as a group and individually, have a long history with the National Broadcasting Company, or NBC, one of the original major networks in the United States, the headquarters of which can be found

at 30 Rockefeller Plaza. It was this network that showed the very first appearance of The Beatles on American television in late 1963.

Three months before their triumphant arrival in New York and their appearance on *The Ed Sullivan Show*, a film clip of The Beatles was shown on *The Huntley-Brinkley Report*, the forerunner to the *NBC Nightly News*. Popular history states that The Beatles' first appearance on American television was on the CBS network *Morning News* on Friday, 22 November, but it was actually the NBC broadcast that came first, showing the full throes of Beatlemania to American teenagers. The third network, ABC, didn't even bother to cover the story. The four-minute piece aired on NBC on 18 November 1963, just a few days before the Kennedy assassination that would also change the world, and allowed The Beatles to be seen by the largest number of people outside the UK up to that point.

In January 1964, another clip of The Beatles was aired on NBC, this time on *The Jack Paar Program*. Paar was by this time hosting his own prime-time show on Friday evenings, having also been the second host of *The Tonight Show*. He had become aware of The Beatles during a trip to England in late 1963, and decided to show some film footage that had been taken at the time. It should be said that none of these programmes – neither the news nor Jack Paar – showed these clips in order to sing The Beatles' virtues. On the contrary, the focus was on the "hysteria" that The Beatles were causing, and on their "outrageous" haircuts. Certainly, no one was paying attention to the music itself, even though The Beatles were always quick to point out its American roots. However, these clips did serve to raise public awareness of the group and to drive advance record sales, so that by the time The Beatles were on *The Ed Sullivan Show*, American audiences were more than ready for them.

Fast-forward to 1968, when John Lennon and Paul McCartney came to the US to appear on *The Tonight Show with Johnny Carson*, which was still being broadcast from New York. The Beatles had just returned from India and were about to begin the recording sessions for what

would become known as the *White Album* and were forming their own company, Apple Corps. They expected to be interviewed by Carson, but much to their disappointment he was on vacation the day they appeared, and the show was hosted by Joe Garagiola, a former baseball player who often served as Carson's substitute. The video of the appearance is lost to time because at some point NBC decided to erase the early tapes of *The Tonight Show* with Johnny Carson, but transcripts do exist, and they show Lennon and McCartney expounding their ideas for Apple and the changes in their audience over the years.

In April 1975, a television program called *The Tomorrow Show* was the late-night follow-up to *The Tonight Show* on NBC, hosted by journalist Tom Snyder. John Lennon did his last-ever television interview on this program, appearing with his immigration lawyer, Leon Wildes, to discuss the details of his deportation case and presenting an appeal directly to the American public about his efforts to remain in the United States.

In the autumn of 1975, *Saturday Night Live* (*SNL*) went on the air. In April 1976, producer Lorne Michaels began what would become a running gag on the show, offering The Beatles the paltry sum of $3,000 to reunite on *SNL*, complete with a close-up of a cheque for that amount made out to the band. Receiving no response, a month later Michaels upped the ante by offering The Beatles $3,200 for their appearance – "an extra $50 each!" Paul McCartney has said that on one of the nights that Michaels made his offer, he was visiting John Lennon at the Dakota, and the two briefly toyed with the idea of showing up at the studio during the live broadcast just to see what would happen, but they never did, so the world will never know what a Beatles reunion might have looked like.

All of the individual members except Lennon have appeared on *SNL* at one time or another. The first was George Harrison, who was the musical guest on the 20 November 1976 show, with Paul Simon as the host. The previous day, Harrison recorded four songs, 'Homeward Bound', 'Here Comes the Sun', 'Rock Island Line' and 'Bye Bye Love',

for broadcast. The first two, duets with Simon, were the only ones that made it on air. In addition, the show's opening featured Harrison and Michaels discussing the $3,000 offer, with Michaels pointing out that the offer was for all four of The Beatles, which meant that Harrison would only get $750 since he was only one-fourth of the band, but that he could give him a little extra if he said the introductory words, 'Live from New York, it's Saturday Night', which Harrison promptly did.

The only Beatle to host *Saturday Night Live* has been Ringo Starr. He appeared on the show on 8 December 1984, poking fun at himself during a sketch depicting a memorabilia auction, and hinting at a "guest from England" who turned out to be cast member Billy Crystal impersonating Sammy Davis, Jr. Starr also appeared in another sketch with Crystal and one with Martin Short. Paul McCartney has been on *SNL* at least six times, on four occasions as the musical guest and two as a surprise addition, in 1980, 1993, 2010, 2012, 2013 and 2015. The last two were uncredited, with McCartney appearing in a sketch in 2013 and at the very end of the show in 2015, with Bruce Springsteen and The E Street Band for a performance of 'Santa Claus Is Coming to Town'. In addition to appearing as the musical guest, McCartney has often appeared in sketches on *SNL*, one of the most memorable of which was with Chris Farley during the 1993 appearance, in which his star-struck interviewer character asked about the 'Paul Is Dead' hoax.

Statue of Liberty, Liberty Island, New York Harbor

The Statue of Liberty is one of the most iconic places in New York. Situated on an island in New York Harbor, it has welcomed immigrants to the United States since the 1880s. It was here in October 1974 that John Lennon, who was at the time fighting a deportation order, went with May Pang and photographer Bob Gruen to Liberty Island with the intention of taking a photo designed to spark deeper support for Lennon's efforts to stay in the country. Gruen's iconic photographs of Lennon, wearing his favorite black coat, a black sweater and a black scarf, have come to symbolise more than his desire to stay in the US – they represent two powerful symbols of personal freedom.

Ellis Island, formerly New York's main immigration processing centre, is the companion to Liberty Island and lies within view of the Statue of Liberty. It was on Ellis Island that Alf Lennon was held for two weeks because he refused to rejoin his ship, *The Samothrace*, and was stranded in New York without a visa. It took him months to find his way home, with Julia not knowing whether he was dead or alive, and with no money being sent home either.

1700 Broadway, Offices of Allen Klein and Apple Corps (between West 53rd and West 54th Streets)

This steel and glass building directly across the street from the Ed Sullivan Theater was home to the offices of Allen Klein, the entrepreneur and businessman who became The Beatles' manager after the death of Brian Epstein. He was the founder of ABKCO Music and Records, Inc. and managed both The Beatles and the Rolling Stones simultaneously. Klein set up what he called 'buy-sell agreements' for his clients, enriching himself, sometimes without the knowledge of his clients. His management of both The Beatles and the Rolling Stones led to years of litigation and accusations of tax fraud; Klein served two months in jail in 1980 for making false statements on his tax returns.

It was here that May Pang, who would later become John Lennon's companion during his so-called 'lost weekend', worked as a receptionist. She subsequently became John Lennon and Yoko Ono's secretary, after helping them with some film projects in 1970, and became their permanent personal assistant in 1971 when they relocated to New York.

The office also served as the US location for Apple Records and the US Beatles Fan Club. The address can be seen on Apple records manufactured in the US.

1700 Broadway, the US offices of Apple Corps.

This address also became the New York office of The Beatles' London-based company, Apple Corps. Most of the staff were old friends from Liverpool, but as the company started having financial problems, they turned to advisors from New York for assistance. The rift within The Beatles that began with the disagreement over whether to have Allen Klein or Lee Eastman manage their affairs would ultimately lead to the break-up of the band.

John F. Kennedy International Airport, Jamaica, Queens

Kennedy Airport (JFK) is the main international airport for New York City. It is located in the borough of Queens, and is the busiest passenger gateway into North America. It opened in 1948 as New York International Airport and was also known as Idlewild Airport before being renamed for President John F. Kennedy after his assassination in 1963.

The Beatles arrived at JFK on Friday, 7 February 1964. Their Boeing 707, Pan Am Flight 101, touched down at 1:20pm, where 5,000 fans were waiting for them on the upper balconies of the terminal, waving banners and screaming, as well as 200 reporters, photographers and cameramen. Also on the plane were Cynthia Lennon, Brian Epstein, Neil Aspinall and Mal Evans. The four Beatles found it hard to believe that this excited reception was for them – they had no idea they were that well known in America, but their music was on the airwaves in the States, particularly after disc jockey Carroll James began playing an imported British single of 'I Want to Hold Your Hand' on WWDC in Washington, DC in December 1963. James gave the record to other DJs around the country and the reaction was immediate.

Additionally, by the time they arrived in New York there had already been extensive pre-promotion by Seltaeb, The Beatles' US merchandising company, which had struck a deal with local New York radio stations WMCA and WINS, promising every fan who showed up at the airport a dollar and a free t-shirt. Capitol Records, The Beatles' American label, had also been promoting the arrival by handing out stickers and posters saying "The Beatles Are Coming" all over New York City. The flight information and time of arrival had been announced on WINS by Murray the K, and that was, in turn, picked up by other stations such as WMCA and WABC. By the time the plane came in, anticipation and excitement were at a fever pitch.

On the steps of a Pan American 707 aircraft after arriving at JFK airport in New York for their first visit to the United States, 7 February 1964. Photo by Popperfoto via Getty Images/Getty Images.

The Beatles held their first American press conference at JFK in the Pan Am terminal. It was here that they met Murray the K for the first time. After the press conference, they were herded into limousines and driven to The Plaza Hotel in Manhattan.

WITH THANKS

Susan Ryan

I'd like to thank my co-authors, David Bedford and Richard Porter, as well as Simon Weitzman, for their encouragement and help and for keeping me on track during the writing of this book. Thanks also to James Smith at ACC Art Books and to editors Andrew Whittaker and Anna Emms, for dealing with all the issues that arose over the past two years, including a global pandemic. Thanks also to my parents, Reva and Jack Ratisher, for putting up with my "crazy Beatles habit" for so many years – my dad didn't live to see this book, but I know that he'd be proud that I've finally turned that habit into something productive! Thanks to my brother, Dave, for understanding how I "sing the song of my people" in the company of other Beatles fans. And last but very much not least, thanks to my husband, Jim, and my son, James, for their infinite patience. I love you both to the moon and back. I would like to dedicate this book to my son, James Daniel Ryan IV, for being there so I could pass on the torch of Beatles fandom to the next generation, and to my husband, Jim Ryan, for putting up with the "other men" in my life. And also to John Lennon, Paul McCartney, George Harrison and Ringo Starr, without whom...

David Bedford

I have been fortunate to have been part of the Beatles family since my first book, *Liddypool*, was published in 2009. I have made so many friends around the world, that helping each other becomes a very natural process. Having known Richard and Susan for many years, writing this book together was also a natural process, with the additional help of our friend Simon. It has been a pleasure and privilege to have worked on this book with them and the amazing team at ACC Art Books. As ever, I would like to thank my wife Alix for her support through all of my Beatles projects, and my family who put up with me! I dedicate this book to Alix; Philippa Ryan and Noah; Lauren and Ashleigh. Also, to the memory of my parents, Colin and June Bedford; my late sister Judy and my in-laws, Alec and Vera Dowbiggin.

Richard Porter

I would like to thank my wife Irina and daughter Lilia for their wonderful support. Mary and David Tucker at London Walks took me on as a Beatles tour guide nearly 30 years ago and I'm still with them now! I've met tens of thousands of Beatles fans from all over the world in that time and I can't thank them enough for the opportunity. I've been lucky enough to meet lots of people who worked with The Beatles – and I would like to thank Rod Davis, Kenny Everett, Pete and Geoff Swettenham, Alan Parsons, Alf Bicknell, Alistair Taylor and many others who have shared their stories with me. It's also been great fun working with my fellow authors David, Susan, and Simon. I would like also, of course, like to thank John, Paul, George, and Ringo for just being...